SIGNAL:07

SIGNAL:07

Signal:07 edited by Alec Dunn & Josh MacPhee
© 2021 PM Press — Individual copyright retained by the respective writers, artists, and designers.

ISBN: 9781629638669 (print), 9781629638904 (ebook)
LCCN: 2020947295

PM Press, PO Box 23912, Oakland, CA 94623
www.pmpress.org
www.signal.org

Design: Alec Dunn & Josh MacPhee

Cover image: Philadelphia Printworks T-shirt designed for the *Soul of a Nation* exhibit at the Brooklyn Museum, 2019. Frontispiece: outside image: detail of the cover of Victor Jara's *Víctor Jara* LP (Argentina: Pathé – 4077/5077, 1967), design by J. Paloma, photography by Patricio Guzmán; inset image—*Within the Shadow of Liberty (Sacco and Vanzetti)*, 1925, by Albert Daenens. Background image (this spread): Feminist assembly at the Darío y Maxi metro station in Avellaneda, Argentina. Photo by Agustina Byrne. Image on following page spread: Unemployed Workers Movement demonstration, June 26, 2002, Buenos Aires, Argentina. Photo by Sub Cooperativa de Fotógrafos Image on contributor page: c/o Centre de Documentació de l'Esquerra Independentista

Printed in the United States.

This is a publication that continuously runs late, and this issue keeps up the tradition. Thanks to all the contributors for your labor and for being patient with us, to Interference Archive, and to everyone at PM Press for their continuing support and patience for this project.

SIGNAL

is an idea in motion.

For the past six issues, we've kept roughly the same introductory statement: "The production of art and culture does not happen in a vacuum; it is not a neutral process. We don't ask the question of whether art should be instrumentalized toward political goals; the economic and social conditions we exist under attempt to marshal all material culture toward the maintenance of the way things are. . . ." *blah blah blah*.

This is all still true, but it says little about why we started *Signal* and why we keep doing it ten years later. It's definitely not for the money. If we kept track, we'd likely discover a hemorrhage that we'd rather not acknowledge. We certainly don't have time, if we did, we would get an issue out more than once every year and a half. This issue in particular is unforgivably late. Most of it was finished in the summer of 2019, but a couple of missed deadlines and a pandemic has pushed it back nearly two years.

Regardless, we still do believe that culture plays a key role in social transformation, and that the writing, studying, and making of political culture should be open to all—especially those involved in said social transformation—not just those credentialized within academia. Our original goal was to carve out a space for clear-eyed and in depth writing about the role and

potential of art in political movements, with a focus on sharing lots of imagery that otherwise wasn't circulating—at least not in our circles. Looking back, it's clear a lot has changed.

For one, social media has made it easier than ever to access the political culture of movements all over the world. At the same time, it is an absolutely terrible archive, with amazing material everywhere one day and gone the next. In addition, our focus was self-acknowledged marginalia when we started. That's not really true today. In our first issue we did an interview with the Taller Tupac Amaru, a collective of printmakers in the Chicanx tradition then barely heard of outside of the Bay Area. Today three of the members are featured in a massive retrospective on Latinx art at the Smithsonian American Art Museum. Our third issue featured a long-format interview with Paredon records founder Barbara Dane—she was recently celebrated by the *New York Times*. That same issue featured a piece on the anti-apartheid group Medu Arts Ensemble, then little known outside of Southern Africa—five years later it was celebrated in a major retrospective at the Art Institute of Chicago.

While our goal is not to be scouts for the mainstream, we do see this as success—not so much for *Signal*, but for the culture of social movements moving from margin to center. We hope that *Signal* can continue to show how cultural work, although often forgotten or shoved to the side as soon as a movement subsides, is at the very center of our lives, and should be celebrated as such.

We welcome submissions of writing on visual cultural production for future issues. We are particularly interested in looking at the intersection of art and politics internationally, and assessments of how this intersection has functioned at various historical and geographical moments.

Signal can be reached at: editors@s1gnal.org

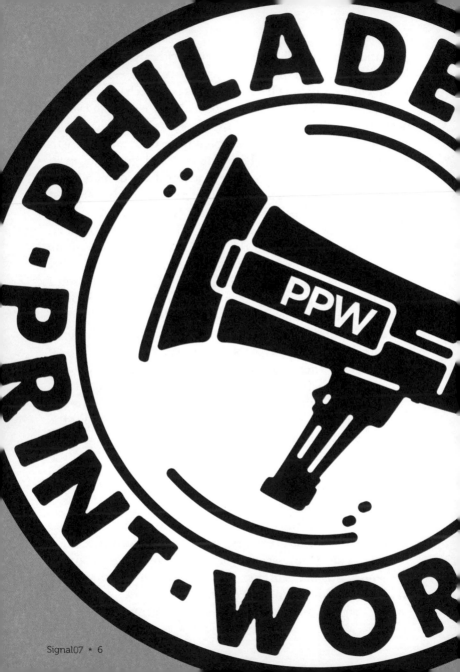

Maryam Pugh grew up in Coatesville, Pennsylvania, a small town located in Chester County, roughly forty miles outside of Philadelphia. After Maryam graduated from the nearby historically Black college Cheyney University, she moved to Philly. In 2008, she worked with Ruth Paloma Rivera-Perez to launch Philadelphia Printworks (PPW), an apparel company that incorporates social justice and leftist messages into its designs while sampling/referencing iconography from the rich history of the Black radical tradition. These shirts and sweatshirts include popular design lines such as Cats Against Cat Calling and School of Thought (designed by Philadelphia Printworks' art director Donte Neal, who injects the tradition of collegiate-wear with a Black political imaginary).

In addition to the company's work in designing apparel, PPW promotes political work through several ancillary arms, including a blog, work supporting local designers and zine makers, as well as building ties with political organizations such as the People's Paper Co-op and the Black and Brown Workers Cooperative. I spoke with Maryam to discuss PPW's history, design aesthetic, and how the company deals with the interrelated challenges of art, commerce, and revolution.

Interview by John Morrison

I want to get a deeper understanding and context for your political thought and how it has developed throughout your life. Could you talk a little bit about your background and what influenced you politically early on?

Sure. That's not something I've spent a lot of time thinking about. But if I had to list a few things that had the most impact on me, I would probably start with my parents. I think my childhood experience was somewhat different than most people I know. I grew up on a farm in a somewhat suburban small town about forty-five minutes outside of Philly. I was the only kid within ten miles that lived on a farm. So I was used to being different from a young age. My father is Muslim and my mother is Christian. So I was introduced to the ideas that religion could coexist and also be contradictory at the same time. When I was very young, I would go to church with my mother. I believe the church instilled into me a number of things . . . but, mostly a supportive Black community that wanted me to shine brightly. My father was largely involved in the Black Muslim community.

Once, when I was about ten, a SWAT team kicked in our door. They were investigating my father for being a part of Black mosques and because, later I would find out, H. Rap Brown had been to our house. My father also had a ton of books around—over time I soaked up a lot.

When it was time for me to go to college, my father was adamant that I go to a historically Black college and university. So I did. I went to Cheyney University, where I discovered the books of Zora Neale Hurston, Toni Morrison, and more. I started an anonymous campus newsletter where I published essays from Mumia Abu-Jamal. I did that for like six months . . . and then got distracted and moved on to something else. Or maybe it was a year. I wish I still had those newsletters.

Do you remember the name of the newsletter?

It was called *Off the Record* and the tagline was the proverb "Tales of the hunt will always glorify the hunter." My friends thought I was crazy.

While at college I was introduced to more ideas around

race and class. I interned in DC for a couple of summers and would go to spoken-word events there. They talked about politics a lot. When I graduated I moved to Philly and I kept going to spoken-word spots where I was introduced to even more perspectives on race and class. And I read a lot.

Wow. Did folks around you think you were crazy because of the political content of the newsletter or because it was a unique hobby for someone your age?

I think it was the political content. But also because it was anonymous and the tone was kind of radical (laughs). I emailed the president asking all these questions about things that were going on around campus. One of my friends said that they would rather join the campus newspaper than do what I was doing. They were insinuating that my means were divisive.

So when I started Philadelphia Printworks with Ruth, I had to quickly develop my political acumen. In the beginning we were interested in bringing awareness to issues that we heard about on NPR and other news sources, basically a top-down approach. Over time I learned that it was and is way more important to amplify messages from the bottom up, starting from the people. Running PPW has forced me to

be responsible about our content. Which means researching topics and staying aware. We also ran a blog for a few years, which pushed me to learn a lot about different political opinions and perspectives.

I still have a lot to learn. Currently I'm really interested in taking a more active approach to learning more about the work that the Philly Socialists are doing. I started organizing with the Philly Bail Fund last summer and I joined the steering committee of the March to End Rape Culture early last year. Organizing work is no joke. And it's different then mobilizing, which is different from activism, which is different from fundraising.

Like I said, I still have a lot to learn.

Why did you feel that urgency to develop your political acumen? Did it feel like you had not yet developed the political capacity to run PPW the way you wanted?

I think that PPW has always been a reflection of my politics. So it can only be as effective as my political awareness is. If I want to be insightful, I have to learn more to do the topics justice. I'm sure I could have gotten away with doing something very superficial and being successful at it. But that's not what I want to do. If I'm truly dedicated to liberation rooted in the understanding

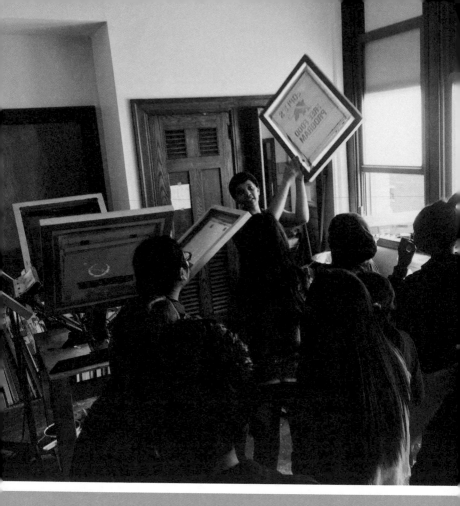

of intersectional oppressions, then I have to learn what that means and what strategies are available to effectively dismantle those oppressions. Then I have to apply that to my resources to see what's possible. That's my mission.

Yes! That makes sense. Moving back a bit, am I right in assuming you had a design background before PPW was launched?

I did not. I went to school for computer science. I worked in the computer field for a decade. I used to draw as a kid

and dabbled in graphic design as I grew older. I have always loved design. PPW was a creative outlet to escape from corporate America.

Could you talk a bit about the early days of PPW's founding? I remember being excited and blown away by some of those early shirts with the images of the MOVE bombing on Osage Avenue and the portrait of Frantz Fanon in particular.

Thank you. Sure. PPW was founded by myself and Ruth Paloma Rivera-Perez in 2008. Our knowledge of screen printing was limited, but we were both very enthusiastic about starting a T-shirt company. We used that enthusiasm to teach ourselves how to screen print, to build and buy the necessary equipment, and to launch our first line. Ruth and I sat down and decided on a list of topics we wanted to address first. That was so easy at that time because we were just getting started and there was so much wrong

with the world. We chose topics like fracking, Monsanto, the Mirabal Sisters, Fanon, Sun Ra, and MOVE. From our limited knowledge of design, we put together a few concepts and came up with what you probably saw. I think the beauty of DIY is that it's supposed to be sort of raw. It's all about people doing what they can with what they have. In some ways the message is more important than the medium, so I guess that played to our benefit. I still have a MOVE shirt. I'm keeping it for my archive. Somehow Ramona Africa heard we were making MOVE shirts and called me up. I was scared, but she was really nice and supportive. She just wanted to make sure I had good intentions.

Wow. And I think that same spirit is reflected in the art, organizing, and general praxis of the whole Black liberation movement. A lot of those folks weren't trained in a lot of the things they were doing. They saw a need and got it done, building their skills and capacity along the way.

Absolutely. We used a lot of collage work for our earliest designs. Most of it was one color because that was the easiest and most readily available to us. It

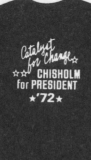

Catalyst for Change
★ ☆ ☆ ★
CHISHOLM
for PRESIDENT
★ '72 ★

Praise
THE
Lorde

RESIST

FREEDOM
Summer

ABOLISH ICE

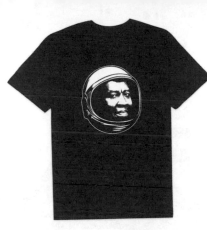

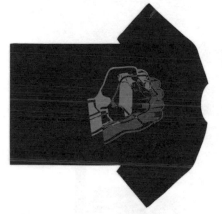

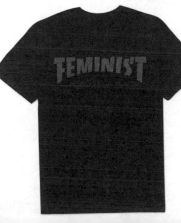

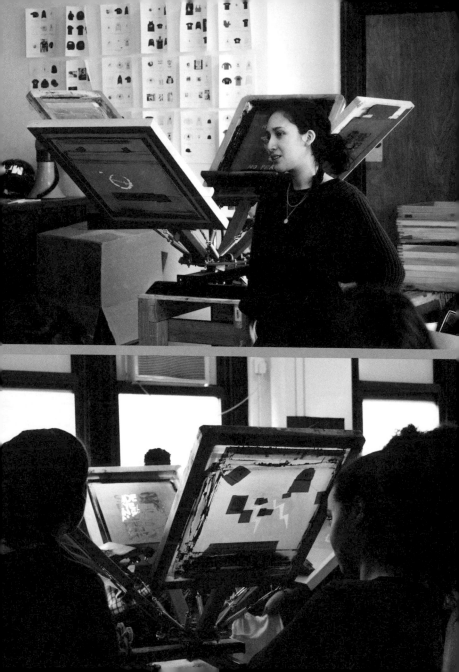

was scary as heck. But it felt more important to get the message out there than to have amazing-looking shirts with zero content. Over time, I hope we've found a way to do both—have content and evolve our aesthetic to be more consumable. But honestly, a lot of those original designs still sell.

I may have said this before, but I've never worn a single item of clothing that I've received more compliments for than my PPW Panther hoodie

Aww. No, I'm not sure that you've said it . . . or at least not quite in that way.

It's true! I remember an elder sister stopped me on the street and was like, "I love your hoodie. I grew up in Oakland and I remember the Panthers would feed me and my mother."

You are not the only person who has told me that same story. I've heard it at least five times from different people!

Damn. That's wild.

That just speaks to the power of the Panther Party and what it has done for the Black community.

Absolutely. Can we talk about the Panthers a bit? I notice that some PPW work takes a lot of visual inspiration from the work of Panther artist Emory Douglas. I assume this is intentional. If so, could you talk a bit about his work and its influence?

Emory Douglas is an amazing artist whose work helped define the Black Panther Party. Our most recent collaboration was with the Brooklyn Museum for the *Soul of a Nation: Art in the Age of Black Power* exhibit. Mr. Douglas's work was heavily displayed there, so it was natural that our collaboration referenced his images. I also think his work is just so iconic. When you think of the Black Panther Party and look at the visuals, the newsletters, the flyers, you see his work. It wasn't until recently that I learned that the panther from the legacy hoodie was actually first conceived by Stokely Carmichael for the Lowndes County Freedom Organization in Alabama, and the graphic was created by Dorothy Zellner. The Panthers asked Carmichael if they could use it for their new party.

You hear a lot of leftist rhetoric about art that comes organically from the people and reflects their lives and struggle. Emory Douglas's work really did that. Shirley Chisholm is another figure that PPW pays homage to. Could you explain why she is so important to you and your work?

I think it's important to excavate our heroes and pay homage to the work that they did before us. It helps define the narrative and to keep their legacy alive. It also serves as a starting point for new activists to build on.

In particular, I admire Shirley Chisholm for her bravery. She set out to do something—become the first Black woman elected to US Congress—that no one thought was possible and she didn't let that stop her. She experienced so much racism and vitriol just trying to be an active part of the democratic process. And she did it because of her love for the people and this country. I admire that.

Word. I've noticed that PPW has embraced the practice of collaborating with designers and groups on new lines. How have you gone about taking on collaborators that align with the brand aesthetically and politically. Does one priority ever outweigh the other?

We always have to align with an organization politically first. Every time. We may work with organizations who use a different approach . . . but the end goal must be the same. Recently, a lot of the organizations we've been working with have been interested in prioritizing the PPW aesthetic in our collaborations. People seem to reach out to us because they like our politics and our aesthetic. And they want to see how we can apply it to their organization, so we haven't really had to compromise much in that way. But we are always cognizant of respecting their own brand aesthetic and try to find the best way to marry both of those things.

There are a few other factors that also play into the decision. If we feel strongly about their mission, then I'll try very hard to find a way to make it work. Which means they may not have an aesthetic at all to build on. But I guess that can be both a pro and a con.

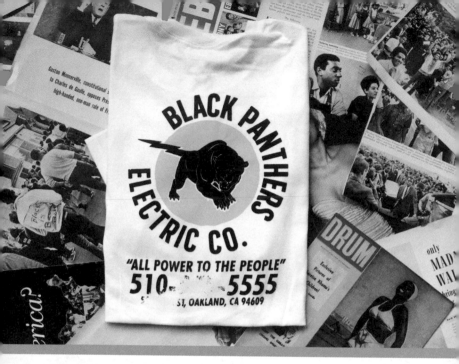

A pro because, with no aesthetic to build on, PPW gets to shape the visual feel of the collaboration?

Right. For example, when we worked with the Women in Re-entry Think Tank at the People's Paper Co-op, they were less concerned with aesthetics and more concerned with messaging. It's important to me that we "pass the mic" and allow marginalized groups to speak for themselves. So we had a graphic designer sit with the women in the program to find out what story they wanted to share. That

graphic designer then translated that into a design that also fit into the PPW aesthetic.

That's amazing. I told you before, but I loved the video piece that you did with Black and Brown Workers Cooperative highlighting their ideology, work, and direct action practices.

Yes, thank you. They're amazing. I'm a *huge* fan of their work.

No doubt! PPW is a successful brand, and your goal is to sell clothes, but you're also

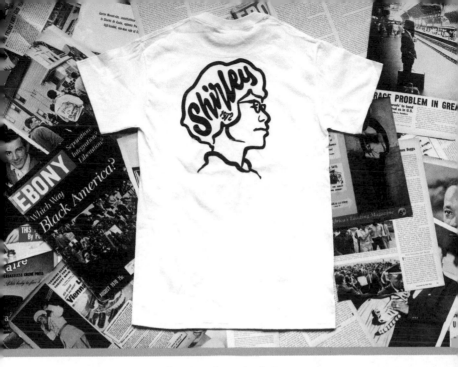

ideologically rooted in the Black radical tradition of the past and aligned with radical organizations today. I'm curious, does that ever cause tension? Personal, if not organizational/professional.

Yes, it does. I feel very conflicted about my role in participating in capitalism. I struggle with feeling guilty about making money off social justice. But I also think that it's important for activists to be paid for their labor. I also try to model a business that is responsible to its community and its employees. I look for ways to use our success to contribute and support social justice movements. But it does little to assuage the psychological guilt.

We had a panel discussion on the role of socially conscious businesses and whether the master's tools can be used to dismantle the master's house. I think we're in an interesting time where a lot of Black businesses are starting. I'm happy to be a part of it. But I think we're still learning how to be held accountable to each other and the communities we serve.

Damn. I could imagine.

There are a lot of difficult decisions I have to make running a business. I have to decide where we source our shirts and what type of labor is used for those shirts. But we also can't afford super eco-friendly shirts because we want to keep our prices accessible. I feel guilty about making compromises, and we're held to an even higher standard because we are a social-justice-oriented company. It's built into our mission.

The thing is . . . no one has done this before. It's easy to make mistakes because there is no roadmap.

I have received criticism for moving into Bok. It was a difficult decision, which has received mixed responses.

[Bok is a South Philadelphia building that once held the Edward W. Bok Technical High School that closed in 2013 and was developed into workspaces for artists and businesses. Many city residents have been critical of the development, declaring that closing a school in a primarily Black neighborhood to create artist lofts aided in the gentrification of the area. —eds.]

Oh wow. That's a tough one. I still haven't been there since it transitioned.

It's hard being held accountable by so many people with so many different sets of politics. But as long as we practice compassion and understanding with one another then I think criticism is an opportunity for us all to learn a lot.

Absolutely. Speaking of a roadmap, can you speak a bit about where PPW is going? What the brand will be/look like in the future?

Yes. I've spent a lot of time over the past year building out the PPW infrastructure so that we can sustain any sort of growth. I think one of the worst things that can happen is an unexpected opportunity before you're ready. So we've been adding to our team and building processes and workflows to streamline our systems. It's very important to me that we hold the means of production. I think the goal of the Black business boom is about building equity in the Black community. I'm very much interested in growing that from bottom to top, as much as possible.

A lot of new T-shirt companies outsource their manufacturing. There are so many companies popping up that will do that work for you. And I love that there's an easy way for Black business owners to get started. But I also feel that there are predatory companies trying to capitalize off the Black business boom without contributing back to the community. We honestly have no idea what their politics are. So recently we started offering fulfillment services for other minority-owned businesses. This means that we run their online store and print and fill their orders just as if they were our own.

That's amazing.

Thank you. That's one division we're growing. We also still do custom printing for social justice organizations. And we'll continue partnering with like-minded organizations doing similar work. It amplifies both of our messaging when we work together. I really enjoy the ecosystem we're building as young Black entrepreneurs, here in Philly, in New York City, in Oakland, and beyond. I look forward to contributing to that.

Long term, I'd like to move our printshop into a warehouse space. I envision the space being an expanded version of our printing and fulfillment center. But also as a community resource for screen printing

workshops and education. I'd like to incorporate some type of skills teaching with a prison reentry program . . . something youth- or women-centric.

And once we do all that, maybe we'll open up a few brick and mortar stores. I think it would be dope to have a PPW in every city that has a large Black community—Oakland, Detroit, Chicago. Although then they'd have to be called Detroit Printworks or Chicago Printworks, but I think that has a nice ring to it!

I'm very interested in the overlapping of diasporic experiences across the nation and globe, finding the intersections. I think that could play out in the stores, where we would highlight national social justice issues plus put a local twist on things.

I remember years ago you were talking about printing zines for people who wanted to make them. It's dope to see PPW expand on that idea in that way. I think that sometimes as leftists with an understanding that Black capitalism is limited, we tend to outright dismiss the importance of Black businesses and the need to grow these businesses as a parallel/ alternative to the white-controlled economy.

Oh my God, thank you for saying that. It makes me feel much better. And yes, Oakland Printworks . . . it feels right! **S**

THE VINYL RECORDS OF

VICTOR JARA

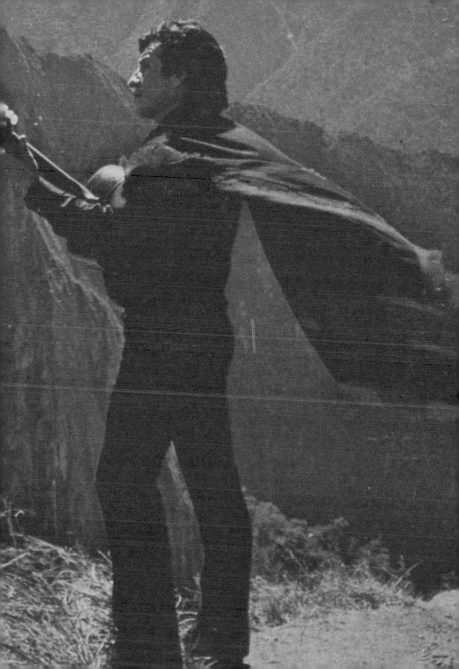

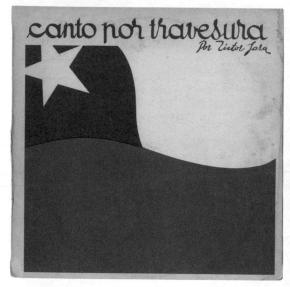

canto por travesura
por Víctor Jara

VICTOR
JARA

CANTANTE
POPULAR
Y HEROE
CHI...

Victor Jara (born in 1932 as Víctor Lidio Jara Martínez) was one of the most popular musicians in the world, yet is largely forgotten outside of Latin America, especially his native Chile. Jara trained in the theater, and in the late 1950s he met Violeta Parra and heard the music of Argentine guitarist Atahualpa Yupanqui, which influenced him to focus on songwriting and performing folk music. In the early 1960s he became deeply involved in the pan–Latin American movement of *nueva canción* (new song), which partnered modern song arrangements inspired by traditional folk music with left-wing political activism. Jara himself had joined the Chilean Communist Party in the early 1960s and became an ardent supporter of future Chilean president

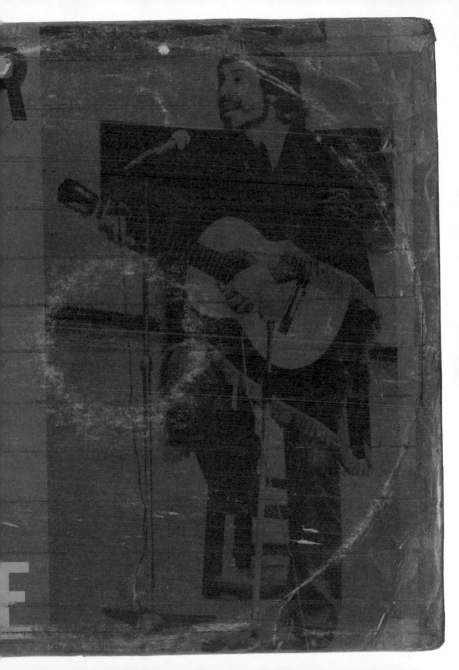

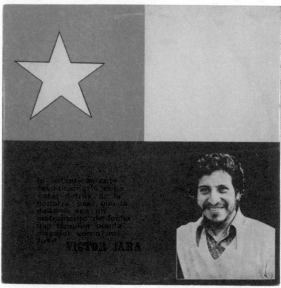

Viva la Resistencia Chilena LP (Mexico: Cleta-UNAM/Mascarones - SRSS 21374, n.d.), cover design unattributed.

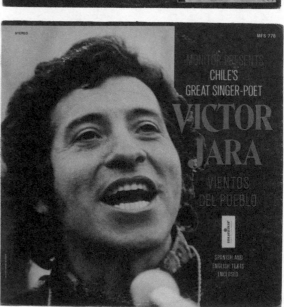

Vientos del Pueblo LP (New York: Monitor Records – MFS 778, 1976), cover design unattributed.

Previous page spread, top left: *Canto por Travesura* LP (Belgium: CEAL - ch 01, 1974), cover design unattributed. Right: *Cantante Popular y Heroe de Chile* LP (Venezuela: PCV - PCV03, n.d.), cover design unattributed. This album was a clandestine production in the 1970s by the then-banned Venezuelan Communist Party.

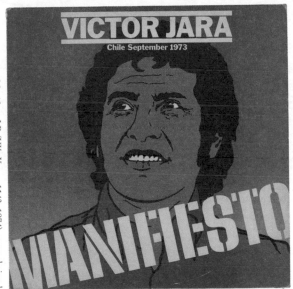

Manifiesto LP (UK: Xtra - 1143, 1974), cover design by Norman Moore.

"Plegaria a un Labrador" b/w "Te Recuerdo Amanda" 7" (GDR: Eterna - 4 10 134, 1974), cover design by Peter Porsch.

Following page spread: *Victor Jara, Presente* LP (Italy: Albatros/DICAP - VPA 8234, 1975), cover design unattributed.

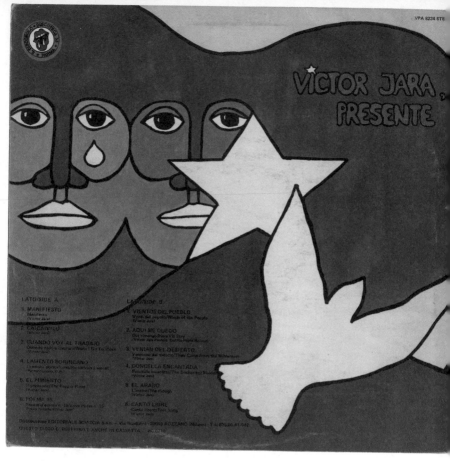

and socialist Salvador Allende. Along with Parra, Yupanqui, Uruguayan Daniel Viglietti, and Argentine Mercedes Sosa, he became one of the most prominent performers of *nueva canción*.

In 1970, Jara wrote the lyrics to the theme song for Allende's presidential campaign ("Venceremos," composed by Sergio Ortega) and performed many free concerts in support of his election. Jara had already gotten under the skin of the Chilean far right by visiting Cuba and crafting multiple songs attacking the police and the church. So it was no surprise when he became a target after the 1973 CIA-backed coup that overthrew Allende and replaced him with the fascist Augusto Pinochet. In the mass

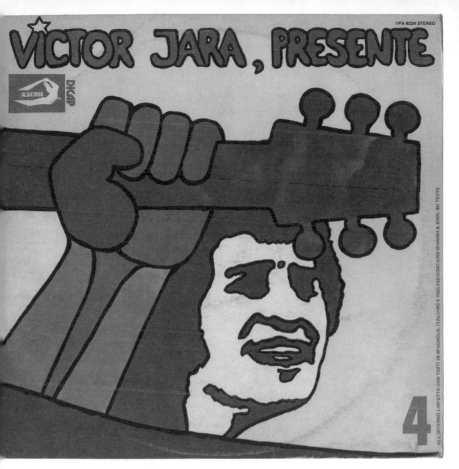

persecution of opposition directly after the coup, Jara was picked up and interned at the National Stadium in Santiago. Upwards of 80,000 people were interned, tens of thousands tortured, and around 2,500 executed.

On September 12, 1973, guards at the National Stadium mangled and broke Jara's hands, it is said that soldiers belittled him after, and demanded Jara play his guitar. Jara was then shot in the head after a gruesome round of Russian roulette, and his body was riddled with over forty bullets. The brutality of the dictatorship ultimately did little to silence Jara's music, as it exploded in popularity and became a beacon for resistance to the Pinochet regime.

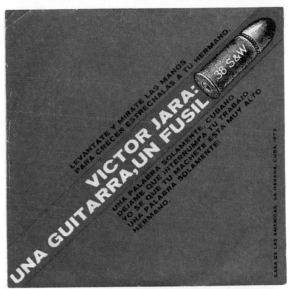

LEVANTATE Y MIRATE LAS MANOS
PARA CRECER ESTRECHALAS A TU HERMANO.

VICTOR JARA:
UNA GUITARRA, UN FUSIL

UNA PALABRA SOLAMENTE. CUBANO
DEJAME QUE INTERRUMPA TU TRABAJO
YO SE QUE TU MACHETE ESTA MUY ALTO
UNA PALABRA SOLAMENTE:
HERMANO.

38 S&W

CASA DE LAS AMÉRICAS. LA HABANA, CUBA, 1973

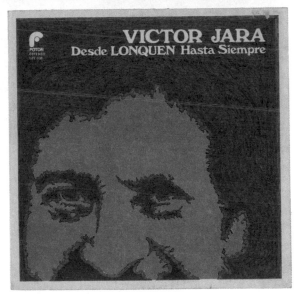

VICTOR JARA
Desde LONQUEN Hasta Siempre

FOTON
ESTEREO
LEY 038

Left: *Victor Jara (Mensaje)* LP (Argentina: Pathé - 4077/5077, 1967), cover design by J. Paloma, photography by Patricio Guzmán; above top: *Una Guitarra, Un Fusil* 7" (Cuba: Casa de las Américas - EP CA-11, 1973), cover design by Umberto Peña; above bottom: *Desde LONQUEN Hasta Siempre* LP (Mexico: Foton - LPF 038, n.d.), cover design by Alberto Aguilar.

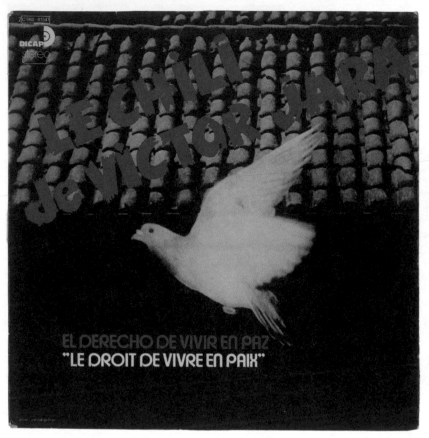

Above: *Le Chili de Victor Jara: El Derecho de Vivir en Paz/Le Droit de Vivre en Paix* LP (France: DICAP/Pathé Marconi - 2C 062-81.541, n.d.), cover photograph by Patricio Guzmán.

Right, clockwise from top left: *Canciones Folkloricas de America* LP (Uruguay: Odeon - URL 20.705, 1970.), cover design by Vicente and Antonio Larrea; *La Población* (Peru: DICAP - DCP07, n.d.), cover design by Guevara; *Levante y Mira a la Montaña* LP (Cuba: Arieto - LDA-3414, n.d.), cover design unattributed; *Compañero Victor Jara* LP (USA: Americanto - A1003, 1976), cover design unattributed; *Pongo en Tus Manos Abiertas . . .* LP back cover (Italy: Comitato Vietnam-Milano - CV1, n.d.), design based on Chilean original by Vicente and Antonio Larrea; *Canto a lo humano . . .* LP (Mexico: RCA Victor - MILS-4192, 1975), cover design unattributed.

Page 39, clockwise from top: *10 Años Cantando con Nosotros* LP (Hungary: Not on label - KR 967, n.d.), cover design by V. Tapia and Pablo G.; *Поети С Китара* 7" and book (Bulgaria: Balkanton - BTK 3803, 1987), cover design by Ivan Kenarov; *La Población* LP (Spain: Movieplay/Serie Gong - S-32.815, 1976), cover design by Vicente and Antonio Larrea.

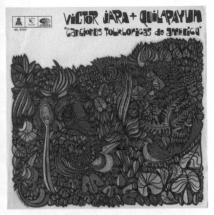

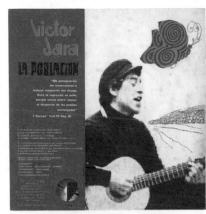

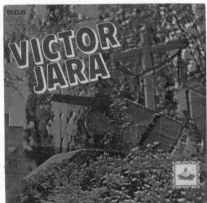

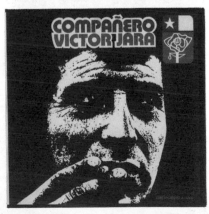

Балкантон

ВТК
3803-A
БЛС 4648-79

СТЕРЕО

405

поёти с китара

ВИКТОР ХАРА

Свободни песен (В. Хара)

ДИ „ХР. Г. ДАНОВ"

MADE IN BULGARIA

Comitato Vietnam
Milano - Via Cesare Correnti, 11

VICTOR JARA
con accompagnamento dei
Quilapayún

33 giri Lato A

1) A LUIS EMILIO RECABARREN
2) A DESALAMBRAR
3) DUERME, DUERME NEGRITO
4) JUAN SIN TIERRA
5) PREGUNTAS POR PTO. MONTT
6) MOVIL - OIL SPECIAL

**SOTTOSCRIZIONE PER
LA LOTTA ARMATA
DEL POPOLO CILENO**

DICAP

**LE CHILI DE
VICTOR JARA**
- EL DERECHO DE VIVIR EN PAZ -
- LE DROIT DE VIVRE EN PAIX -

STEREO

2C 062 - 81.541 1

1 - LA PARTIDA (3'13)
 Victor Jara
2 - EL NIÑO YUNTERO (3'43)
 Miguel Hernandez - Victor Jara
3 - VAMOS POR ANCHO CAMINO
 (3'15)
 Victor Jara - Celso Garrido
4 - A LA MOLINA NO VOY MAS
 (3'13)
 Folklore du Pérou
5 - ABRE LA VENTANA (3'56)
 Victor Jara
6 - EL DERECHO DE VIVIR
 EN PAZ (4'35)
 Victor Jara

Victor JARA
avec le concours de
I. ILLIMANI et
P. CASTILLO

MADE IN FRANCE

**Discoteca
del Cantar
Popular**

VICTOR JARA

33⅓ R.P.M.
003 Lado A

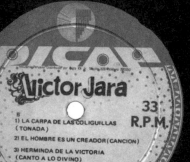

DICAP

Victor Jara

33
R.P.M.

B
1) LA CARPA DE LAS COLIGUILLAS
 (TONADA)

2) EL HOMBRE ES UN CREADOR (CANCION)

3) HERMINDA DE LA VICTORIA
 (CANTO A LO DIVINO)

4) SACANDO PECHO Y BRAZO (CUECA)

5) MARCHA DE LOS POBLADORES
 (Todos)

DCP- 07.

Areito

LA MUSICA CUBANA ALREDEDOR DEL MUNDO
PRODUCIDO Y DISTRIBUIDO POR EGREM MARIANA-CUBA

VICTOR JARA
El Derecho de Vivir en Paz

33
R.P.M.
LDA-3414
CARA A

EL DERECHO DE VIVIR EN PAZ-MUSICA Y LETRA: VICTOR JARA
ABRE LA VENTANA-MUSICA Y LETRA: VICTOR JARA
LA PARTIDA - MUSICA: VICTOR JARA
EL NIÑO YUNTERO - MUSICA Y LETRA SOBRE POEMA DE M. HERNANDEZ
VAMOS POR ANCHO CAMINO-MUSICA: V. JARA-LETRA: V. JARA
A LA MOLINA NO VOY MAS-FOLKLORE PERU DEL PERU

KR 967

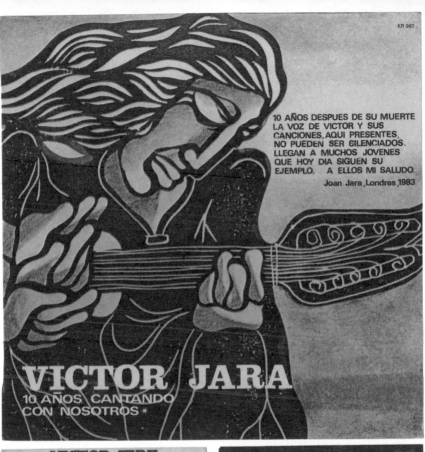

10 AÑOS DESPUES DE SU MUERTE
LA VOZ DE VICTOR Y SUS
CANCIONES, AQUI PRESENTES,
NO PUEDEN SER SILENCIADOS.
LLEGAN A MUCHOS JOVENES
QUE HOY DIA SIGUEN SU
EJEMPLO. A ELLOS MI SALUDO.

Joan Jara, Londres, 1983

VICTOR JARA
10 AÑOS CANTANDO CON NOSOTROS *

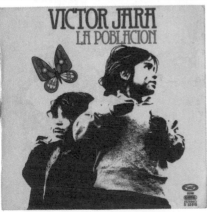

VICTOR JARA
LA POBLACION

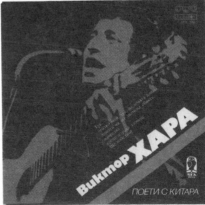

Виктор ХАРА

ПОЕТИ С КИТАРА

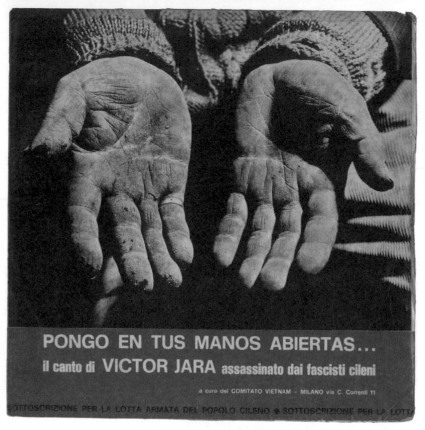

Between 1966 and his death he released eight albums, with a ninth partially completed. This small, concentrated discography has been added to with multiple live albums and compilations, and overall, his records have been pressed by nearly seventy-five different record labels in over twenty-five countries. His songs have been covered by dozens of musicians as diverse as US folk stalwarts Joan Baez and Pete Seeger, Chilean metal band Vigilante, French jazz pianist Collete Magny, and pop stars Bruce Springsteen and Robert Wyatt. In addition, dozens of acts have referenced Jara in their songs, including The Clash, Irish songwriter Christy Moore, the Bronx-based hip-hop act Rebel Diaz, and Simple Minds. **S**

Left: *Compañero Victor Jara Presente!* poster which came folded up in the Peruvian pressing of *La Poblacion* (Peru: DICAP - DCP07, n.d.), artist unattributed; above: *Pongo en Tus Manos Abiertas . . . il canto di Victor Jara assassinato dai fascisti cileni* LP (Italy: Comitato Vietnam-Milano - CV1, 1976). Cover design based on original Chilean cover by Antonio Larrea.

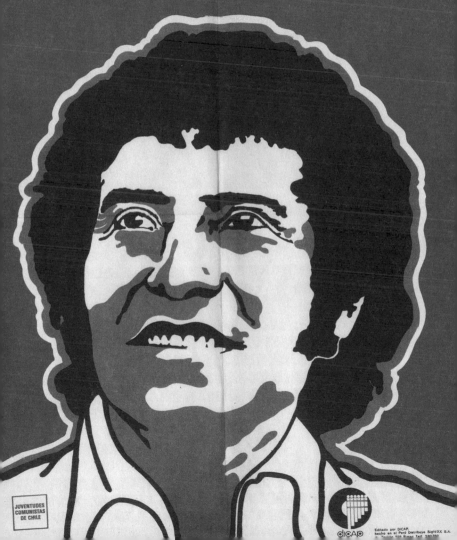

COMPAÑERO
VICTOR JARA
PRESENTE !

Editado por DICAP.
hecho en el Perú Distribuye SigloXX S.A.

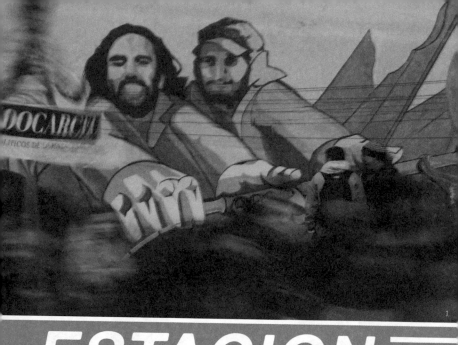

ESTACION DARIO Y MAXI

by Natalia Revale

In 2001 Argentina was in the midst of a severe economic crisis that had been precipitated by a crushing national debt and subsequent austerity measures imposed by the International Monetary Fund. Mass movements that had been building for the previous decade exploded on the streets in December 2001 demanding restoration of basic government services and support. Following this the Argentine government—at the behest of then-president Eduardo Duhalde— began to crack down on the increasingly militant political actions organized by the autonomous Movimientos de Trabajadores Desocupados (MTDs, also known as the Unemployed Workers Movements and commonly referred to as piqueteros). These groups, consisting primarily of poor and working-class people living in the industrialized cities on the edge of Buenos Aires, organized protests, neighborhood assemblies, and created vibrant neighborhood counterinstitutions such as workshops and autonomous food and health care networks, as well as arts and cultural programming. Additionally, the MTDs supported the metamorphosis of businesses and factories that had been recently shuttered into self-managed workers' cooperatives.

On June 26, 2002, several MTDs organized a coordinated action to block the roads into Buenos Aires. One of these blockades took part in Avellaneda, a heavily industrialized city directly to the south of the capital. There, activists closed down the Pueyrredón Bridge, one of the major highways into the city, but were forced back by riot police, tear gas, and gunfire. As the protestors retreated, the police followed. On the streets of Avellaneda, Maximiliano "Maxi" Kosteki, a young MTD activist was shot by the police and carried by them into the Avellaneda commuter rail station. Darío Santillán, another young MTD activist, ran into the station to help his fallen comrade. In a moment captured on video, Darío placed himself between Maxi and the police and held up an outstretched arm, palm outward, in an attempt to hold off attack, while his other arm supported the injured Maxi. The police then assassinated Darío and Maxi with shotguns with live ammunition.

June 26 was the day on which Darío and Maxi were murdered. It was also the day their family members, friends, and comrades began a

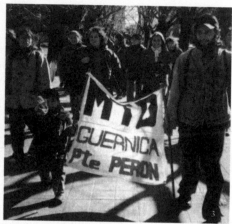

Left: Darío Santillán, undated.
Right: Maximiliano Kosteki (holding the banner), at an MTD protest, 2002.

long struggle for justice, so that their murders would not be forgotten or go unpunished.

Darío Santillán grew up in public housing in the working-class suburbs of southern Buenos Aires. He became politically active in his teens, and following high school he began to work in the MTDs. Darío worked with youth as a mentor and instructor of media literacy and journalism and participated in the creation of people's libraries. He was active in housing struggles and volunteered his time to work as an organizer and bricklayer to build housing for unemployed and landless young families. He was well respected in the unemployed movement for his discipline and commitment to the struggle and was a popular presence in the neighborhoods. At the time of his murder he was twenty-one years old.

Maxi Kosteki was a fresh face in the MTD. Maxi, like Darío, grew up in the suburbs of southern Buenos Aires. He had only recently become active with the MTDs, in May of that year, and he had volunteered with local food, garden, art, and library projects. He was a painter and musician who planned to enroll in art school. The June 26 blockade action was his first as an MTD activist. At the time of his murder he was one week shy of turning twenty-three.

Quickly, many in the neighborhood rallied around these martyrs. In the immediate aftermath, protests were staged on the street in front of the station and on the Pueyrredón Bridge, and memorial murals and site-specific interventions were created throughout the neighborhood. An arson attack on the Avellaneda station, committed to obscure evidence that implicated the police, kept the interior of the station shuttered for two years after the attack. But in 2004, during a monthly street demonstration to demand justice, the doors of the station were forced open and activists then painted over the station's signs, changing them from "Avellaneda" to "Estación Darío y Maxi." This initial action initiated a flood of activity, with activists continually changing the official signage on the train platform and installing art, photos, sculpture, ceramics, murals, and graffiti within the station. Musical performances occurred and theater was staged. Cumulative cultural organizing transformed the station into a platform and space for activists and relatives of victims of police and institutional violence to gather and organize.

In January 2006, following intensive protests and investigations, Alfredo Franchiotti and Alejandro Acosta, the two policemen that

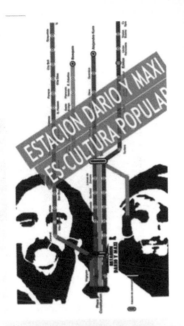

4

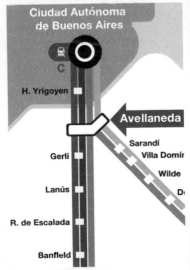

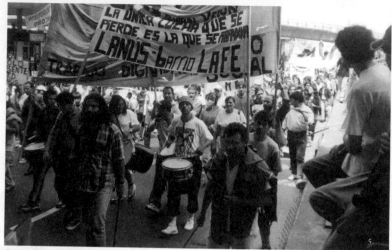

Darío Santillán (in plaid shirt), at an MTD march in 2002.

fired the shots, were sentenced to life in prison. Three other police officers were sentenced to four years in prison for conspiracy in the cover-up of these murders (as well as numerous minor sentences and suspensions to other members of the police).

In 2008, our collective, the Frente Popular Darío Santillán, obtained the legal right to manage the vacant lot next to the station. We built an amphitheater, a sewing studio, and a textile workshop where today dozens of cooperatives work. Everything was built by colleagues from the Frente Popular Darío Santillán, an organization which formed out of the merging of local piqueteros, students, and artists.

It is important to note that our relationship with the state, its resources, and the station itself, is in constant struggles around power and control. None of our victories would have been possible without the popular struggle: our murals, our installations, our protests, and our memorial on the twenty-sixth day of every month (from 2002 to today)—where we shut down the street in front of the station for one hour to demand justice. Nor would any changes have been possible without our annual mass mobilizations where we occupy this same area, every June 25 and 26, for twenty-four hours of celebration, resistance, and remembrance. This is how in 2013, the name of the

station was officially changed—by Congressional decree—to the "Estación Darío Santillán and Maximiliano Kosteki," although the name had unofficially been changed years earlier.

Art and culture can be used as forms of militancy, of denouncement, and as vehicles for creating life. The transformation of the Avellaneda Station into the Darío Santillán and Maximiliano Kosteki Station was a decades-long project carried out by artists, cultural workers, activists, and social organizations. The station is now one giant artistic/political intervention, each piece speaking to Darío and Maxi's memory, and the station itself is an ode to the struggle for justice. The works at the train station are in constant dialogue with the issues of human rights and state violence. The space is curated in a very intersectional way, with works that reflect many struggles—for the rights of women and indigenous peoples, and in defense of natural resources, among others. Anticipating that public works tend to deteriorate over time, each artist carefully chose materials—such as clay or iron—so that the work will last as long as possible. With this in mind, murals were made from ceramics, rather than simply painted, and the station's pottery workshop and kiln ensures that these ceramic murals can be produced and maintained on site.

The experience of placing the station into community hands was innovative and has become highly pedagogical. As a result of the actions in and around the Darío and Maxi Station, other public spaces in the area have been occupied and transformed, through artistic interventions, into sites of resistance and memory.

The road ahead involves holding accountable those politically responsible for the murders of Darío and Maxi, principally the former president of Argentina Eduardo Duhalde. In the meantime, we know that Darío and Maxi will be names that fall off the lips of thousands of workers as they buy tickets and ride the train. A curious child will ask who they are. History is crafted through the symbols that reflect the values we hold. We remember Darío and Maxi by honoring the solidarity, creativity, and bravery that colored their lives and struggles of these young men. We know that their stories will remain rooted in our collective memory. **S**

On the following pages is a brief graphic history of the art and activism around Estación Darío y Maxi, with accompanying notes.

The Beginnings

These are images from the June 26 action on the Pueyrredón Bridge in Avellaneda, 2002. The action demanded unemployment subsidies, an increase in social welfare programs, and freedom for MTD activists taken as political prisoners. Officials threatened that a blockade would not be tolerated, and military and national police were added to local police forces in an attempt to control the protests.

The police forces attacked the protesters on the bridge with clubs, gunfire, and tear gas, causing the crowd to flee back into the neighborhood.

The images here show the protesters and police on June 26. On the upper right, Darío (with a mask and a hat on) is helping a comrade move away from danger. Below that we see Darío and Maxi in the train station. The image on the left shows Darío helping Maxi and telling the police to stop. The police attacked, and when Darío ran he was shot in the back.

Finally, we have an iconic drawing by Florencia Vespignani from 2002 that reproduces the scene, amplifying the size of Darío's hand as a way to emphasize the gesture of solidarity. This gesture and motif became one of the most recognizable symbols of this day, and has continued to multiply in stencils, flags, murals, and T-shirts.

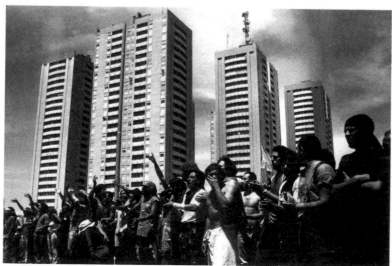

6

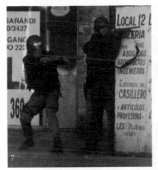

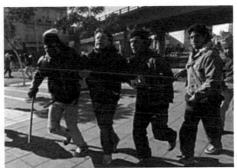

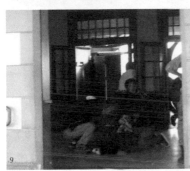

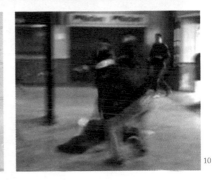

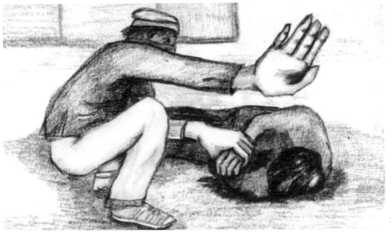

There have been numerous protests over the last two decades in memory of Darío and Maxi, in protest of state violence, and against police impunity.

Every year, on June 25, there is an all-day and all-night cultural festival with music, theater, speakers, and art. And on June 26, there is a large demonstration in commemoration of the anniversary of the Avellaneda Massacre, where relatives of Darío and Maxi and activists from different organizations speak.

There are also monthly memorials held on the street in front of the station. Darío and Maxi's comrades protest outside the station for one hour, demanding justice and accountability for the murders.

To the right: An image of volunteer security for a protest in 2008. The activist in the center is wearing a patch with an image of Darío that was repurposed from a T-shirt he wore at his first memorial protest years before.

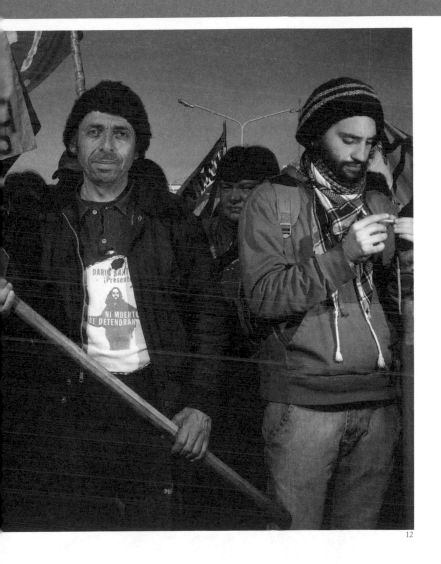

Below: Large-scale "wanted" posters indicting some of those politically responsible for the murders, including Argentine president Eduardo Duhalde and governor of the Province of Buenos Aires, Felipe Solá. Hung from the Pueyrredón Bridge, June 26, 2005.

Top right: During the yearly memorials, a large feminist assembly is organized to accentuate the visibility and contributions of our sister comrades to the piquetero movement. This photo is from 2016.

Below right: The "Flag of Flags" mobilization, on the five-year anniversary of the Avellaneda Massacre, where artists and organizations were called upon to show up with flags and banners to honor the martyrs and highlight the goals of the movement. Pueyrredón Bridge, June 26, 2007.

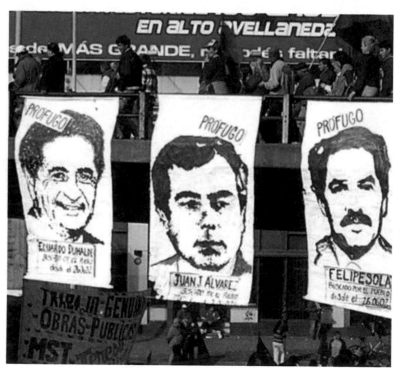

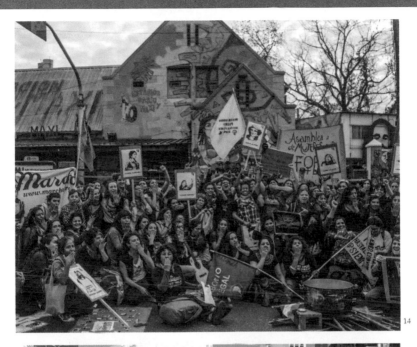

14

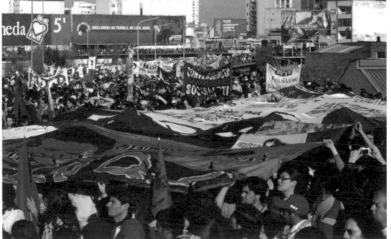

15

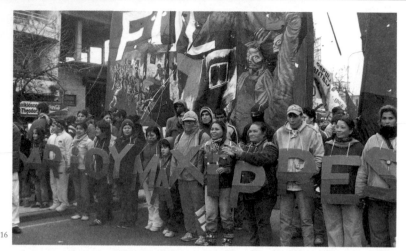

16

Above: Memorial protest, 2003.

Below: Memorial protest on the Pueyrredón Bridge, 2018.

Facing page: Burning an effigy of former President Duhalde during a cultural event and protest at the station, June 25, 2009.

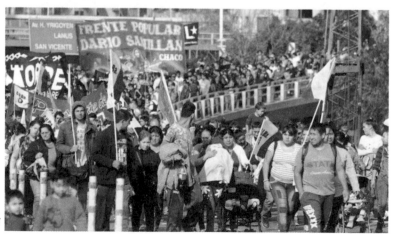

17

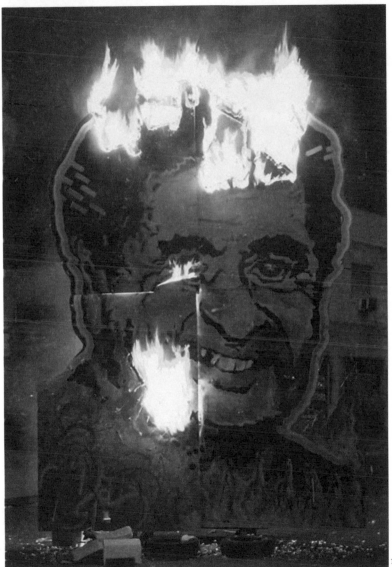

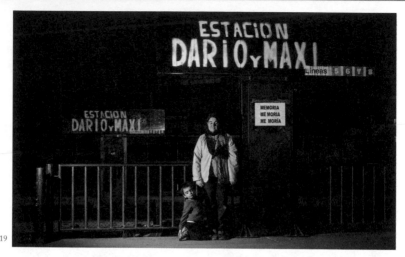

19

On the twenty-sixth day of each month for many years, we took advantage of the street action to change the name of the station, either freehand with paint or with a large stencil. Usually, the train workers painted the sign black and rewrote "Avellaneda" afterward, but there were months when they did not come and the Estación Darío y Maxi sign remained.

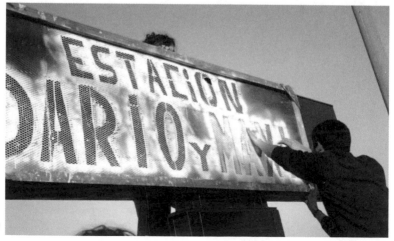

20

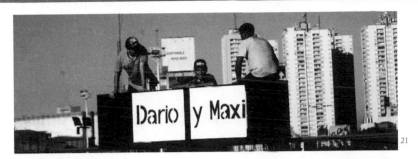

21

22

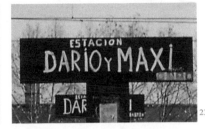

23

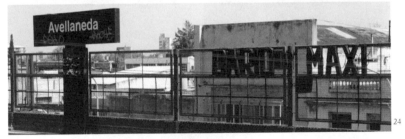

24

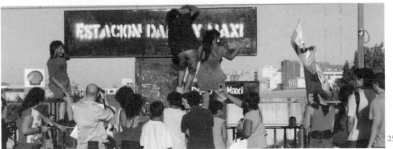

25

Interventions

The station now has more than fifteen years of cumulative artistic interventions. Many of them no longer exist, but some are preserved. It is very interesting, when we lead tours of the station, to be able to tell the story of this struggle through the interventions: who made it, when, and with what technique. Over the years, we have made calls to artists to bring their work and have also organized meetings of muralists to paint the walls of the station and surrounding neighborhood. The station has become a cultural center and place of exchange through visual interventions.

Facing page: The first ceramic mural, at the base of one of the staircases from the train platform, made in 2008.

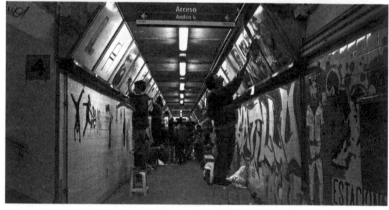

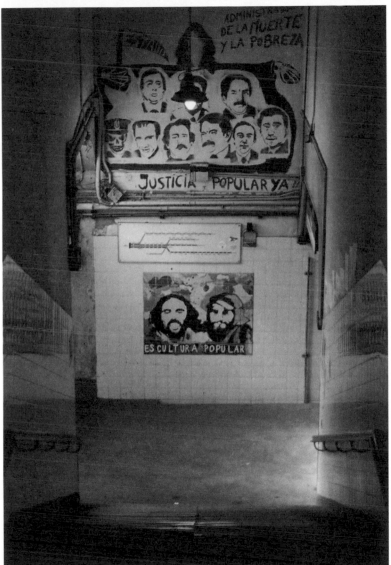

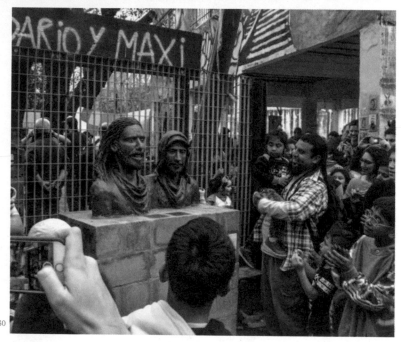

Above: Sculpture of Darío and Maxi, by Alberto Díaz. To the right is Leo Santillán, Darío's brother, with his son in 2018.

Facing page top: Painting around the ticket counter by Fileteadores del Conurbano, 2018. It would eventually be inscribed with a quote from Che Guevara, "Above all, be capable of feeling deeply any injustice committed against anyone, anywhere in the world."

Facing page middle: Ticket/pass intervention. The banner reads, "Six years in our fight for justice / Darío and Maxi presentes / Attention: Do not take a ticket!!!" Action occurs yearly, every June 26. For many years the ticket office remained closed throughout the day in response.

Facing page bottom: Counterfeit ticket intervention, "We Do Not Forget. Free Ticket," 2009.

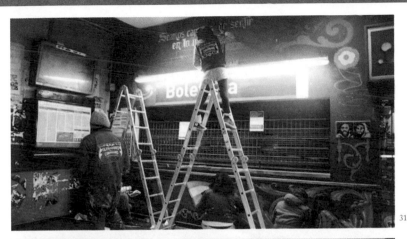

31

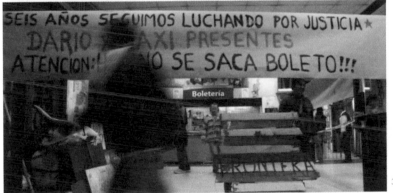

SEIS AÑOS SEGUIMOS LUCHANDO POR JUSTICIA ★
DARIO Y MAXI PRESENTES
ATENCION:!! NO SE SACA BOLETO!!!

Boletería

32

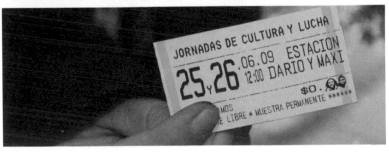

JORNADAS DE CULTURA Y LUCHA
25 Y 26.06.09 ESTACION
12:00 DARIO Y MAXI
$0.
E LIBRE ★ MUESTRA PERMANENTE ★★★★★

33

The first mural memorializing Darío and Maxi was painted in the immediate aftermath of their murders by students, friends, and the Contraluz mural group. The top image is of the mural being painted during a protest on July 26, 2002. The second image shows the mural near completion shortly afterward.

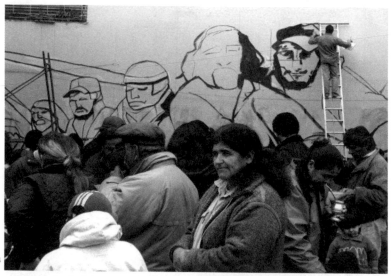

34

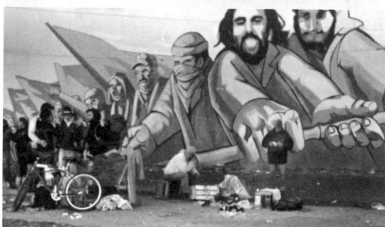

35

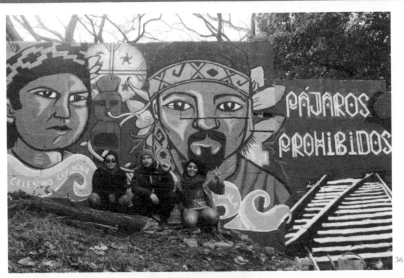

36

Above: A mural painted
by the Newen Che group,
following an open muralist
meeting at the station in
2018, depicting indigenous
Mapuche activists impris-
oned for defending their
land. The title *Forbidden
Birds* refers to a text by
Eduardo Galeano.

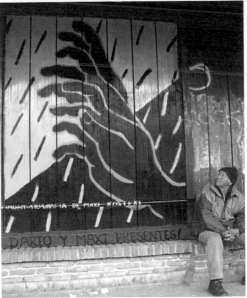

Left: A mural recreating a
drawing by Maxi Kosteki,
painted on the exterior of
Darío and Maxi Station,
2005.

37

These images show the slow transformation of the train station itself. The top left image shows sporadic graffiti, and a stage being set up prior to a cultural action (2005). On the bottom left is Mexican muralist Gustavo Chávez Pavón painting the front of the station (2011). On the facing page are details from the most recent murals by the group Muralismo Nómade en Resistencia (2018).

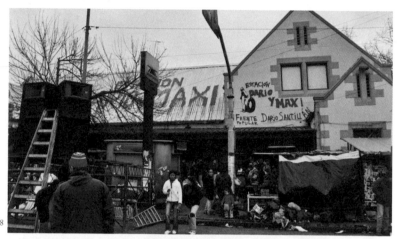

38

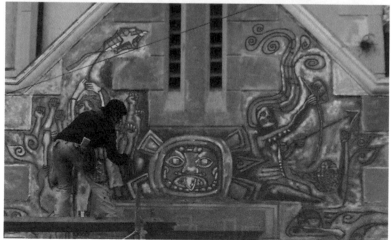

39

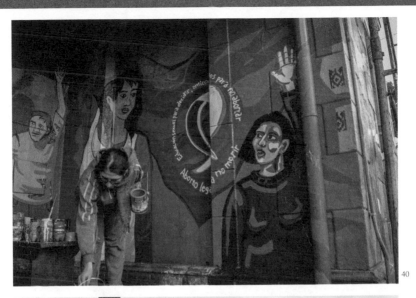

40

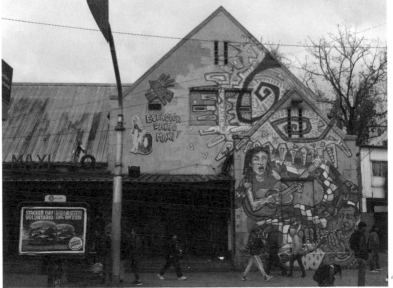

41

42

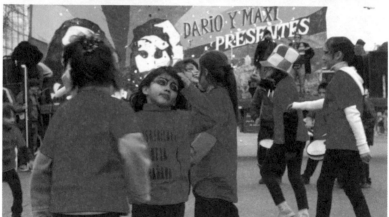

43

"I feel proud to be Darío's father," said Alberto Santillán, pictured above, receiving memorials of his son designed by children. Looking over a crowd of many young organizers he said that he doesn't feel alone: "In each one of them, I also see my son."*

Below: A children's dance and performance at a 2011 memorial event. Children are a fundamental part of the cultural activities, a spirit of joy that renews our struggle.

*Francesca Fiorentini, "A Decade without Dario and Maxi." *Upside Down World,* July 2012, upsidedownworld.org.

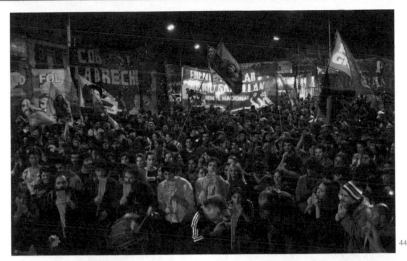

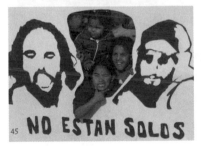

NO ESTAN SOLOS

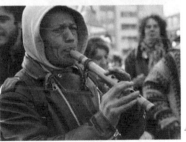

Above: One of the twenty-four-hour cultural festival at the station. In the front is a group of people playing sikus, an instrument used in the folk music of the Andean highlands of South America, 2012.

Below left: Children posing in a photo stand between images of Darío and Maxi, "You are not alone." Created for *Arde Arte!* (Burning Art!), a gathering in Lomas de Zamora, 2005.

Below right: Marcial, a close comrade of Darío, plays the quena during every demonstration and memorial. Marcial is also depicted playing the quena on the station's front mural.

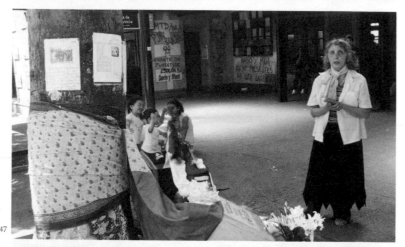

47

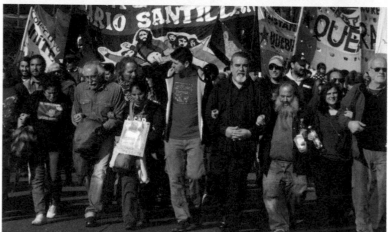

48

Above: Altar and Ceremony for Darío Santillán by Mabel del Anden, poet, activist, and Hare Krishna. She baptized Darío as a piquetero saint.

Below: Memorial march with relatives of Darío and Maxi and human rights activists, 2016.

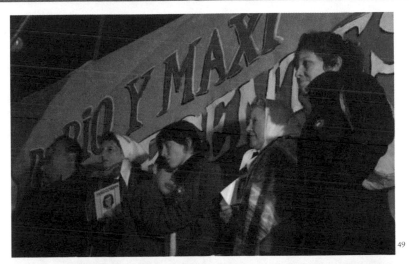

49

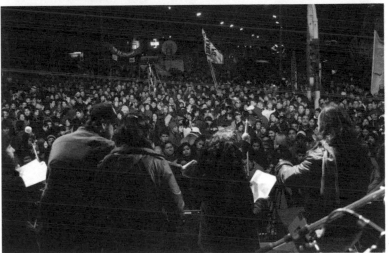

50

Above: Memorial celebration for relatives of the victims of repression, pic-
tured in attendance were some of the founding Madres de Plaza de Mayo in
their iconic white kerchiefs, on the nine-year anniversary of the Avellaneda
Massacre, 2011.

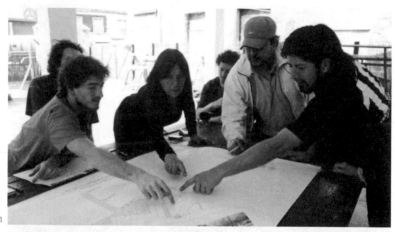

51

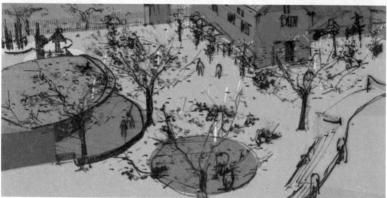

52

Next to the station there was an abandoned lot of land where, on the twenty-sixth of each month, we organized an assembly after symbolically closing the street as we demanded justice for the murdered.

We began to imagine creating a space that could host assembly meetings and cultural activities. By negotiating with the government, as well as with a lot of persistence and a permanent presence in the streets, we managed to recover a section of the lot and build an amphitheater. An architectural sketch is presented here.

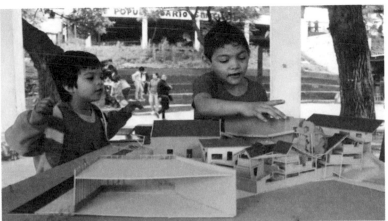

53

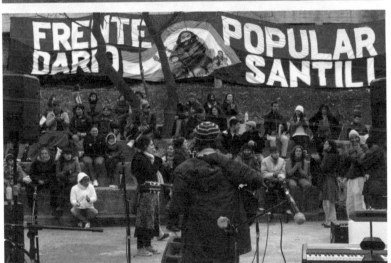

54

Above (left and right): Community input sessions for architectural plans, 2013. Below left, an early sketch by the Taller Libre de Proyecto Social of a proposed conversion of the lot next to the train station from 2008. Below right: Performance following the establishment of the community constructed amphitheater, Darío and Maxí Station, 2011.

55

56

57

Opposite: The metallic murals on the opposing page, were made by the workers of a metal workshop who, on each anniversary, create a piece of monumental political sculpture. Far from considering themselves artists, they participate in a worker-owned space in order to do this kind of solidarity work beyond their daily tasks. These workers were Darío's comrades.

Above left, the iconic image of Darío and Maxi mounted to the rail bridge in front of the station in 2012. Below, silhouettes of Darío and Maxi, mounted to the side of the cooperative sewing workshop building, 2012.

Above: Ceramic workshop with children, beneath the cooperative sewing workshop, 2014.

Above: Inside the cooperative sewing workshop, 2012.

Below and opposite: Images from a 2019 collaborative ceramics project, with the Madres de Plaza de Mayo, that took place in the station's ceramic workshop. Ceramic overlays were collaboratively created with symbols honoring their struggle, which has been ongoing for forty-five years since the military coup.

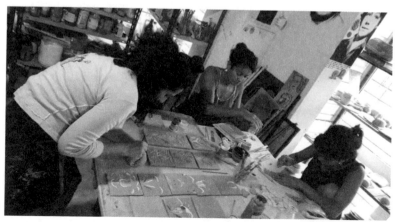

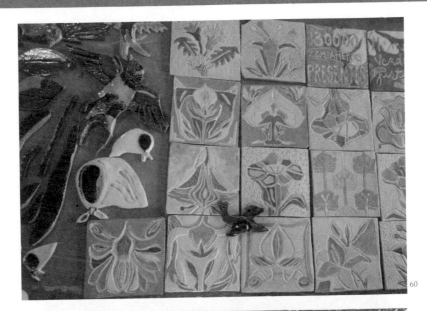

60

61

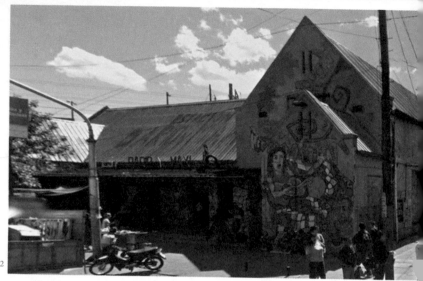

62

In 2013, after years of protests, actions, and sustained pressure, the National Congress formalized the name change from Avellaneda Station to Darío Santillán and Maximiliano Kosteki Station. The changes on the station's signs were officially made October 1, 2014. Pictured is a recent street view (including the cultural space to the right), a ticket from the station, and the station entrance.

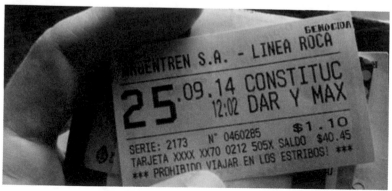

63

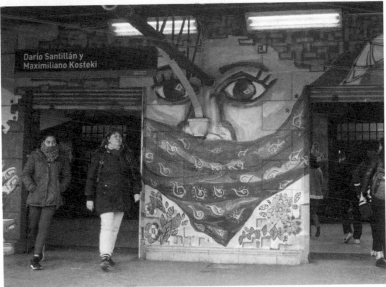

Darío Santillán y
Maximiliano Kosteki

Following the struggle for Darío and Maxi Station, two other Metro stations in Buenos Aires have had their names changed, one being the Rodolfo Walsh Station, in memory of the leftist journalist killed in 1976 during the military dictatorship in Argentina. The station was rechristened in his honor in 2012.

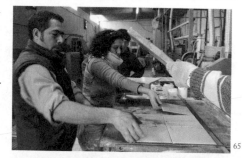

Tactics refined in the struggle for Darío and Maxi Station were applied in this process, notably in the creation of a ceramic mural of Walsh, which was produced in the FASINPAT-ZANON tile factory that had been taken over by its workers.

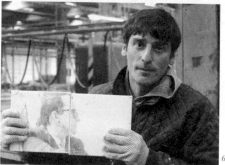

The second station to have its name changed is in the Balvanera neighborhood of Buenos Aires and is now called Once–30 de Diciembre, named in memory of the 194 young people killed in a nightclub fire on December 30, 2004, who were unable to escape due to the lack of enforcement of safety measures. The station now has several permanent installations in their honor, including a hallway lined with the names of the dead and several site-specific murals.

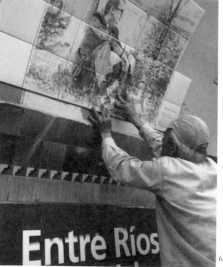

Image Credits

The author and editors have done their best to credit artists and photographers. With an archive of hundreds of images from dozens of activities over twenty years, and with an activist project of this scope and time frame, some names have unfortunately been lost along the way.

For further documentation about the struggles around Darío and Maxi Station, there are two documentaries available on YouTube:

- *Estación Darío y Maxi, ex Avellaneda*, directed by Ricardo Von Muhlenbrock
- *La crisis causó dos nuevas muertes*, directed by Patricio Escobar

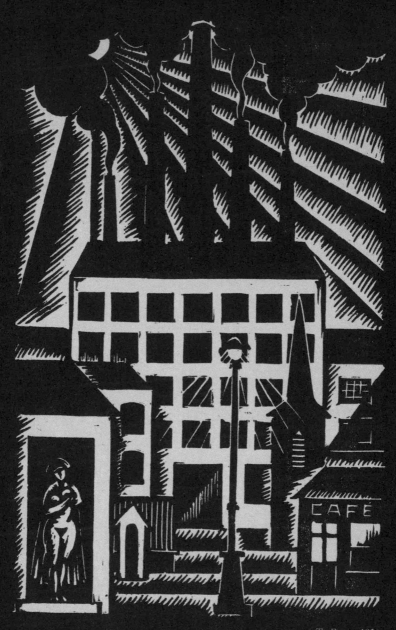

The Factory, 1926

WE WILL BREAK OPEN THE
ALBERT DAENENS 1883 1952
DOORS THAT OBSCURE THE SUN

Albert Daenens was a writer, artist, printer, stage designer, and publisher. A Belgian anarchist, he believed in the necessity of an art that amplified the struggles of working people. With activities and projects that spread across multiple and diverse disciplines, it is difficult to give a succinct description of him. This might be one of the reasons he has remained obscure—by not excelling in one particular domain or another, he is still rather unknown. So who was Albert Daenens? What did he do? What did he stand for? How did he work? And finally, why should we remember him and give him a place in Belgian and international political art history?

BEGINNINGS

Louis Albrecht Daenens, who went by Albert, was born in Brussels, Belgium, on February 27, 1883. His mother was Eugenia Daenens (1863–1891), then nineteen years old, his father unknown. Eugenia, a tailor in the theater, died when Albert was only eight years old. After that he was largely raised by his grandparents and his aunt Malvina, also actively employed in the Flemish theater— anything connected to the theater would be of lifelong importance for Daenens.

Daenens grew up in an artistic household. His grandfather was both an actor and an amateur painter. Daenens was a talented student and at the age of sixteen he enrolled in the Royal Academy of Fine Arts in Brussels, where one of his teachers was the painter Adolphe Crespin, and there Daenens won several prizes.

After leaving school he began to work in the theater, but due to a physical disability—one leg was deformed—dreams of a career as a leading actor could be forgotten. Regardless, he remained active in the world of the spectacle by directing and designing sets. People called Daenens "Bère Notje," referring either to him being "small as a nut" or to his shortened leg. Early on, Daenens designed the sets for the play Philip II by Emile Verhaeren, a Flemish playwright and poet (with an affinity to anarchist ideas and personally associated with the French anarchists Jean Grave and Félix Fénéon), and his work met with some acclaim.

EARLY ANARCHIST CONTACTS

By 1912, a police report states that Daenens and his comrades were under surveillance as dangerous anarchists. Daenens most likely became embroiled with radical politics in the Brussels alternative café scene, especially the cabaret Le Diable au Corps. We can infer that it was there that Daenens started to build himself a network of multiple, sometimes overlapping passions and communities. His interest in radical politics, avant-garde art, French literature, and Flemish theater came together in such places. The café-cabaret was a meeting place

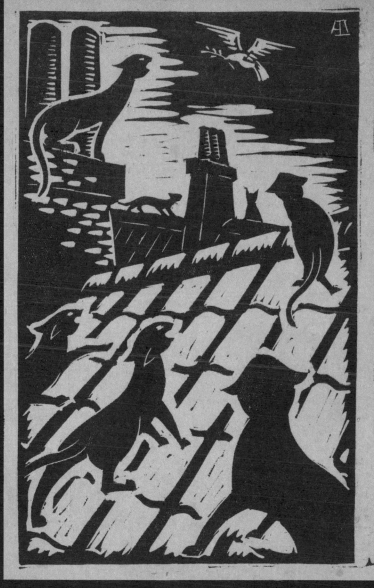

Where Can I Land?, 1928

for Flemish theater people and French-speaking students from the Université Libre de Bruxelles, mixed with a diverse group of intergenerational artists and poets of both languages. Some of these young revolutionaries wanted to create their own literary-political-artistic magazine that broke radically with the past. During this time, Daenens collaborated on at least three of these journal attempts: *La Foi Nouvelle* (The New Faith, February 1912–March 1913), *En Marge* (In the Margin, July 1912–September 1913)—both radical literary magazines, and the anarchist *Le Révolté* (The Revolt), in which he was listed as acting manager in 1913.

For Albert Daenens, his involvement in the anarchist milieu was always part and parcel of his artistic activities. In a certain way, Daenens can be seen as part of the bridge between the anarchist movement at the beginning of the century, with luminaries such as Victor Serge, Rirette Maîtrejean, Raymond Callemin, and Jean de Boë—all of whom were linked one way or another to the Bonnot Gang—and the Belgian postwar anarchists Hem Day and Ernestan (Ernest Tanrez).

LITERARY ARTISTIC SOCIOPOLITICAL JOURNALS

In Belgium, prior to the First World War, there were many small avant-garde cultural-political magazines, and they were often interconnected. I will focus on a few Albert Daenens was involved in, including the previously mentioned *La Foi Nouvelle*, *En Marge*, and eventually *Haro!* The first edition of *La Foi Nouvelle* appeared in February 1912 and presented itself as an artistic, literary, and social magazine. Its mission was stated in poetic form:

Oh! Small wooden gods and small stone saints,
What crimes for you in this amassed era!
The people no longer believe. Your fine days are past;
Weep in Your Vatican, Successor of St. Peter
The Almighty, alas, is only a chimera
That our abused senses went to seek in heaven
In incensed vapours but an artificial rite
Sleepy, mysterious, like an ephemeral dream.

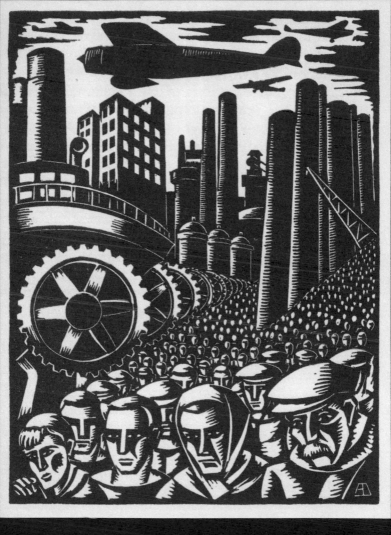

Servitude, ca. 1933

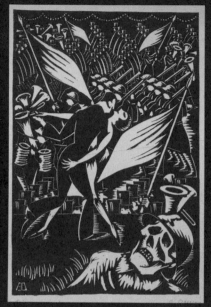

Left: *Ten Years After*, 1928. Right: *Right to the End!*, 1920.

Albert Daenens was a contributor to *La Foi Nouvelle* from its first issue. He designed the cover template, which would be reused and reprinted in different colors over the years. This image, a blossoming tree with rising sun, was typical for the politics of the magazine and similar to iconography used by many left-leaning arts publications at the turn of the century.

Starting with the second issue, he began to write articles for the magazine. Daenens was listed as editor of the applied arts and he wrote and illustrated what would become a regular column within the publication titled "La Hotte" (The Hood). For his inaugural column, Daenens published this manifesto against vanguardism:

> [This is a call] to the real artists to revolt. As we can't expect anything from the current social state, salvation will come to us from the people, the inexhaustible source of new energy. Let us

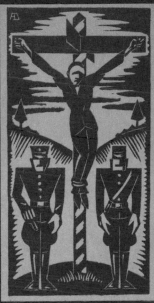

Left: *The Reign of Order,* 1920. Right: *Conscientious Objector,* 1928.

prepare with them the revolution, which will chase away this bourgeoisie without ideals, without soul, and without brains.

Previous manifestoes by artists such as Henry van de Velde (a Belgian and one of the founders of art nouveau), held up the artist as a member of the avant-garde, one who leads by pushing forward. On the contrary, Daenens clearly wants to walk the road together with the people.

Starting in the sixth issue of *La Foi Nouvelle* Daenens began to design small illustrations for different sections of the magazine, and also contributed a full-page caricature on symbolism. For the double November/December issue in 1912 he wrote a rather acid critique on religion and in 1913, the second year of the magazine, one on alcoholism and poverty. He also illustrated a short "tragedy in one scene" by Jules Mellaerts, *La Mansarde,* in March

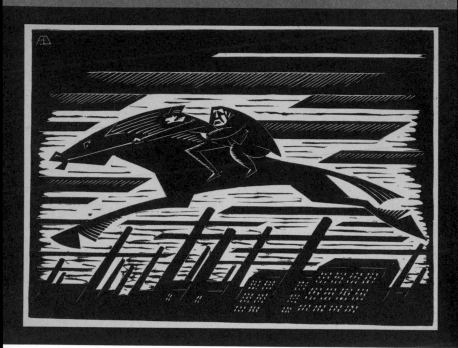

The Accursed Hunting, 1928–1929.

1913. The drawing, depicting a dying young woman suffering from tuberculosis, could well be inspired by the death of his lover, Alice Lebègue, some months earlier.

In July 1912, several writers from *La Foi Nouvelle*—including Abel Gerbaud, Paul Ruscart, and Léon De Roos—founded another magazine, *En Marge*, to defend and promote the new ideas in art and literature.[1] Daenens also collaborated, and here he met War Van Overstraeten, artist and later cofounder of the Belgian Communist Party, with whom Daenens would continue to collaborate throughout his life. For this period, we find an interesting source about this young artistic revolutionary—a police surveillance report:

> Daenens, Louis Albert answers to the following description: / Size 1m55 to 1m57 / Lean and bony figure / Rather yellowish complexion / Blond-red hair, fairly long / Beard

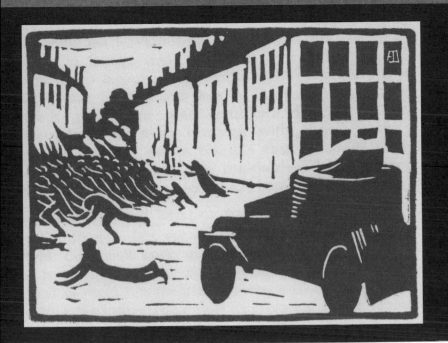

Lead Rations, 1919

blonde-red, square / Limps with the right leg and has there-
fore an unsteady tread / Always wears a large soft felt hat
with wide edges and a "La Vallière" tie.[2]

The successive publication dates of these little magazines shows
that perhaps *En Marge* existed as the transition from *La Foi Nouvelle*
to *Haro!*, but the influential arrival of the writer Maurice Casteels
at *La Foi Nouvelle* should be appreciated.[3] His first contribution, "Il
Faut Détruire Carthage" (The Need to Destroy Carthage), was an
anarchist-inspired rant published in the October 1912 issue. Casteels
was not a newcomer; he helped found the periodical *Le Cynique* and
brought many of the people involved in that publication over to *La
Foi Nouvelle* and later to *Haro!*

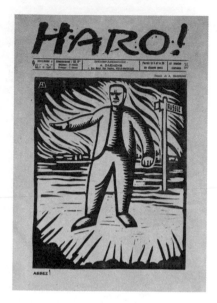

Above: N. 29/Nov. 1919/"Enough!" Below: N. 1 (3rd series)/Oct. 1927/"Great American . . ."

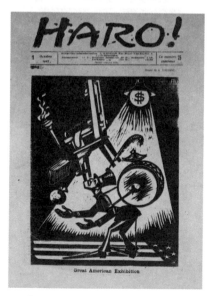

Great American Exhibition

HARO! FIRST SERIES 1913-1914

In 1913, Albert Daenens and Maurice Casteels cofounded the magazine *Haro!* Like its predecessors, *Haro!* was lavishly illustrated and concerned with the arts and modernism, but it situated itself in an even more explicit political stance. *Haro!* emerged with the following program printed in its initial issue dated June 1913:

> *Haro!* is the first journal of action in Belgium of modern art in its most intransigent acceptance. The contributors to *Haro!* will cover current events at the same time as literature and art. For if the artist's mission demands silent solitude, he must nevertheless listen to all that may interest other men, and if he interferes with their actions, he will show them heroism.

The front pages of *Haro!* always consisted of a full-page drawing (and for the second and third series full-page linocuts) by Albert Daenens (the one

exception was in October 1913, which presented a half-page illustration by Daenens (titled *Down with the Schools*). Within the first two issues we rediscover his friends, the French artists Abel Gerbaud and Marcel Bouraine, but also Ferdinand Schirren and then a certain O. Petyt, most likely Oscar Petyt. Issues three and four provide another surprise, illustrations by the fauvist Rik Wouters and the symbolist painter Léon Spilliaert. Wouters is quite logical because he and Daenens knew each other from the Brussels-Brabant area, as part of an informal artist group later described as Brabant fauvism. In the first issue of *Haro!* Daenens wrote a positive review about him: "Rik Wouters, a sculptor, has . . . the heavy task of showing painters the new trends in painting. He managed admirably." In October 1913, a drawing made by Wouters accompanied an article on the right to abortion. The connection with avant-garde artist Léon Spilliaert may seem more astonishing, but if we look at a lesser known element from Spilliaert's extensive

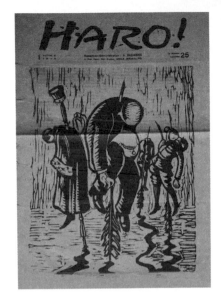

Above: N. 25/July 1919. Below: N. 10/May, 1920/ "What would I do without socialist ministers?"

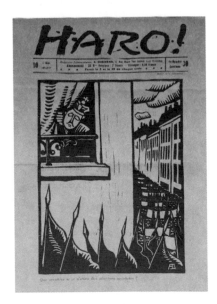

career—from symbolism to Dada—we discover that in the first years of the twentieth century he made work with social themes, such as *Foule massée sous un drapeau noir* (Crowd massed under a black flag) in 1904. This might very well depict an anarchist rally. Finally, we should mention the artist Charles Counhaye, whose illustrations appear in the second series of *Haro!*[4] Clearly an interesting group of avant-garde artists was in contact with Daenens and Casteels.

The first series of *Haro!* ended suddenly, without warning, with the double issue no. 6-7 in January 1914. The radical pacifist ideology of the magazine was well known, and in a period in which war rhetoric had become increasingly amplified, even among some avant-garde artists who gave way to nationalist regurgitation, magazines like *Haro!* found it difficult to survive.

THE WAR YEARS

During the first years of the war, Daenens activities are not easy to reconstruct. His constant poverty led him to rely heavily on friends, some of whom were later considered collaborators with

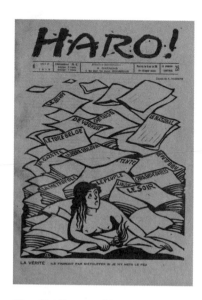

Above: N. 4/Aug. 1919/"THE TRUTH: They'll end up choking me if I don't burn them." Below: N. 6/Sept. 1920/"And Then?"

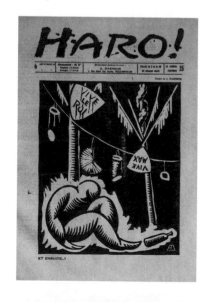

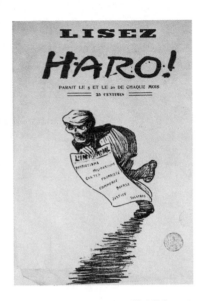

Above: poster promoting *Haro!* N. 1. Below:
N. 3/Aug. 1919/"To die for the fatherland,
it's the most beautiful fate (popular tune)"

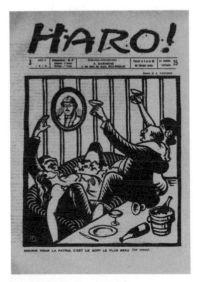

the occupying German regime, which will have consequences for Daenens after the war. In the case of Willem Gijssels, we can reasonably assume that he and Daenens probably met each other in the prewar years before at the café-cabaret Le Diable au Corps. Gijssels, eight years older, and today known mainly for some corny Flemish hymns, had been involved with the artistic-literary anarchist group De Kapel (named after an abandoned chapel in which they held their meetings in Antwerp) around the turn of the century.[5] Gijssels also contributed to the avant-garde artistic journals *Alvoorder* (Avant) and *De Ontwaking* (The Awakening), which included articles by anarchists Peter Kropotkin, Jacques Mesnil, and Ferdinand Domela Nieuwenhuis. In 1916, Gijssels became chief editor of *Vlaamsch Leven* (Flemish Life) and in that position gave Daenens a press pass, which was important because with it Daenens could visit museums and galleries for free. In return, and because he needed the money, Daenens worked as an illustrator for the journal. The style of these illustrations shows

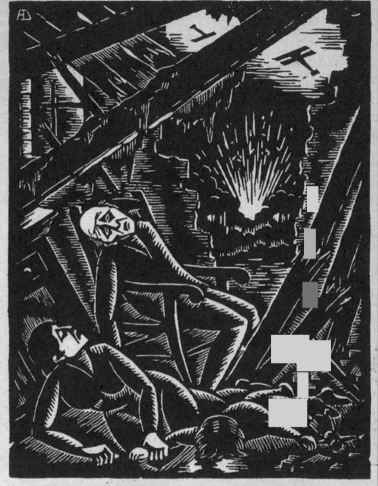

TERWIJL HUN MANNEN SNEUVELDEN...

While Their Men Died, ca. 1920s.

no experimentation or artistic challenge whatsoever, they were clearly work for hire. If we look at his other, more personal work of that period, we'll see Daenens experimenting with heavy black-and-white contrasts, like in his illustrations for publications by Maurice Roelants.[6] Proud of these books, Roelants mentioned that "Albert Daenens cut the plates and binding in pear wood, while the writer learned the noble art of printing."

In 1918, Daenens contributed to the Greater Dutch nationalist journal *De Toorts* (The Torch), with which many exiled Flemish activists participated. This contact was facilitated by Gijssels, probably to help him earn a living, because afterward there was some correspondence about payment problems. Yet his illustrations, although similar in style, are nothing like the innocent images used for *Vlaamsch Leven* but full-page cover drawings in line with the reactionary ideology of the journal. This is odd, and it is not clear that Daenens held the same views, especially considering his radical left-wing political views before and after the war, but nevertheless they can be regarded as ideological statements in support of Flemish nationalism. A few months later, the war was over and Daenens fled to the Netherlands. His friend Félix De Boeck remembered: "In the spring of 1918 [Frits van den Berghe] was at my place and Albert Daenens made him a false passport, with which Frits was able to go to Holland."[7]

In the Dutch artist village of Blaricum, where Frits van den Berghe lived in 1916, an artists' colony of exiled Flemish formed at the end of the war, with the brothers Jozef and Jan Frans Cantré, the poet René de Clercq, and others. Daenens visited them, which would prove fruitful for the second series of *Haro!*

HARO! SECOND SERIES 1919–1920

After his stay in the Netherlands, Daenens returned to Belgium. This postwar period is rather complicated for Daenens. Many of his acquaintances and friends collaborated with Germany during World War I, in the belief that this would further the Flemish cause (and these tendencies led some toward real collaboration with German

Nazis in World War II). Due to historical events, the left-wing position of the Flemish avant-garde has long been disregarded, as if there was a kind of stain working backward. Interestingly, we can witness something similar through the personal evolution of a few French-speaking writers such as Paul Ruscart, Paul Colin, Michel de Ghelderode, and René Baert, just to mention a few people from Daenens's circle of friends.

So indeed in 1919 Daenens began the second series of *Haro!* Despite recurrent financial problems again, this is the most fertile time for the magazine. As in the first series, Daenens designed the covers and produced some smaller illustrations inside. Other artists (many now well known) contributed as well. *Haro!* started its re-inaugural issue with following manifesto:

> The most abominable crimes ever devised against peoples have been committed by governments. The most horrible of wars has just ended. In the name of old and false conventions, ten million men, the youngest, the most entitled to life, have just been mown down and forever defeated. . . . Comrades, help us to overthrow this rotten old building! Help us to make the revolution, to drive away the undesirable and the bad. (. . .) Then, with a final and unanimous blow of a pickax, we will break open the doors that obscure the sun. We shall make the mouldy, decaying, lifeless old world crumble at our feet forever.

In the publication *Art Libre*, the resurrection of *Haro!* was announced as follows, "We signal the birth—or better the resurrection—of the sympathetic libertarian journal *Haro!*, which, under the direction of our confrère Daenens, vigorously fights the good fight."[8]

The ideological content changes a bit as *Haro!* becomes even more antimilitaristic. The first issues contained illustrations primarily by Daenens, with the exception of two drawings by "FE" (Daenens's lifelong friend Félix De Boeck) in the second issue and a satirical

Above Left: N. 7/Oct. 1919/"Souvenir." Above right: N. 8/Oct. 1919/"The 14 Points of Wilson or the 36 candles of old Europe." Below left: N. 5/Sept. 1919/"If only I could put this in my soup." Below right: N. 2/July 1919/"The Triumphal Way."

drawing by his old friend Charles Counhaye on the involvement of two big industrial players in the war (the arms manufacturers Schneider and Krupp) in the third issue, with two additional Counhaye images in issue five. While Daenens's previous imagery was a continuation of his slightly Brabant impressionist-fauvist prewar style, he used now a more contrasted, expressionistic way of drawing. It must be noted that he was influenced by the material he had to work with—linoleum was a cheaper alternative to wood—and he developed a more clear-cut style as a result of this.

With number six, published in November 1919, things really changed. Artistically this second series of *Haro!* became the most interesting, because next to the aforementioned illustrators, graphic work by Jozef Cantré, Frans Masereel, Frits Van den Berghe, and Paul Joostens were also published. I can identify two other contributors then living in Blaricum, writing under the pseudonyms Nele and Vesa, as the art historian Juliane Gabriel and her future husband, Dr. Victor Cnop. After publishing issue 6, Daenens appears to have run out of capital. It took until May 1920 before the next issue saw light, thanks to the donations and efforts of friends of the journal and its politics. Daenens's biting full-page cover of issue 7 showed the Belgian king scared, hiding behind a window curtain, and overlooking a workers' demonstration, saying, "What would I do without socialist ministers?" This issue is also important because it contains an excerpt of Clément Pansaers's *L'Apologie de la paresse* (Apology for Laziness), published here for the first time. Originally written in 1917, this Dadaist piece shows that *Haro!* was open to new artistic tendencies. This new direction lasted for three issues (nos. 6–8), and by June 1920 the second series ended.

Recently another interesting contact of Daenens has emerged. His archive holds a lost radical antimilitarist and antireligious play by the Dutch artist and De Stijl founder Theo Van Doesburg. This play was handed over to Daenens to translate into French for publication in *Haro!* The translation was made, but the publication never took place.[9] Indeed, between the second and third series of *Haro!*, a few words need to be said about his artistic career. Probably through his

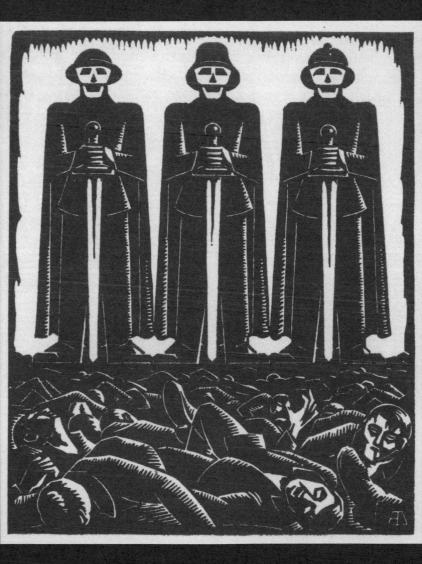

Peace, 1933.

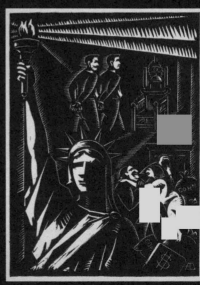

contact with Theo Van Doesburg and the De Stijl group, Daenens started experimenting with abstraction. In September 1924 he contributed an undated abstract linocut to the French neoplasticist magazine *Vouloir*. In the following year, some of his more figurative linocuts were published. The most intriguing publication of his work is in late 1926, for the "Lyrisme?" issue of *Vouloir*, in which he has two abstract, very forward-looking linocuts, one dated 1924 and one that he seems to have made in 1919. In his archives this work bears the date "1919–1924" in pencil, and written over it "191?–1924" in black ink, so it can't be guaranteed it was indeed made in 1919. It wouldn't be the first time an artist predated work to look more avant-garde. But then again, given the contact he had with Van Doesburg, this could indeed be a very early experimental abstract work.

Another contact—from the north of France—and contributor to *Vouloir*, is Maurice Wullens, who edited the pacifist artistic-literary journal *Les Humbles* for many years. Daenens made several contributions to it. Wullens will defend Daenens when Maurice Casteels (Daenens's former collaborator), in a 1924 article for *Mercure de Flandre* about linocut as a revolutionary art in Belgium, didn't even mention Daenens, except with a deliberately vague "one of them."

> This one of them is our comrade Albert Daenens, the illustrator of the Kraskreml, by Henri Guilbeaux But back to Casteels. Why does he not mention Daenens? Does he not know him? . . . They cofounded the beautiful magazine *Haro!* before and after the war: Casteels dealing with the literary part, Daenens with the artistic program. *Haro!* was among the first Belgian magazines to publish linocuts. Better than that: Daenens illustrated Casteels's prose collection *Banalités* with five linocuts, and in *Esthétique* (both of them editions of the Pot d'Étain in Brussels) the only modern lino (and awfully reduced!) was by Albert Daenens. Come on, another little hatred, some jealousy! So much pettiness among these writers!

Clockwise from top left: *The Inquisitor*, 1928. *The Dictator*, 1926. *Within the Shadow of Liberty (Sacco and Vanzetti)*, 1925. *Spring*, 1925.

Even though Casteels wanted to marginalize Daenens, his work was still very much in demand. In 1927, Manuel Devaldès, a French anarchist individualist writer exiled in London, contacted Daenens for illustrations for a new book he was preparing. Even though donations were asked for in *Les Humbles*, not enough money was raised for the book to be published.

HARO! THIRD SERIES 1927–1928
WWII AND AFTERMATH

In 1927, the third series of *Haro!* was published. This time the political program was again even more libertarian and pacifist, with among others, the aforementioned Manuel Devaldès, Ernestan, and Mil Zankin contributing. For literary criticism, a certain Babylas signed on, which was none other than the famous avant-garde Belgian writer Michel de Ghelderode. There were no more illustrations running along the text, but the full-page front cover was, as always, by Daenens. The third series of *Haro!* lasted roughly six months, and consisted of five issues.

A highlight in Daenens's post-*Haro!* career is the publication in 1929 of *20 Linos Pamphletaires*, an album that chronologically collected his best linocuts from 1919 to 1929.[10] The foreword was written by his friend René Baert.[11] This album was even sent to Gandhi. Indeed, Daenens became more and more involved in the international pacifist movement. His work appeared in antimilitarist magazines and journals all over the world, but his commercial art career stalled. The Second World War again brought misery to Belgium, and once more Daenens had to beg his friends for work, but some of these friends were now collaborating with the Nazi occupiers. Daenens's view on the world became very bleak. By 1937, he had moved to the small village of Drogenbos, not far from Brussels and close to his lifelong friend Félix De Boeck. He did occasionally work with the local amateur theater group, as a director as well as a set designer. His situation steadily declined, and by the end of his life he was living in real poverty. It was noted that Boeck's wife brought him a bowl of soup every day in order to make sure he didn't starve.[12]

On August 25, 1952, at the age of sixty-nine, Daenens died in a hospital in Uccle. And then, for many years, he was forgotten. It is only by recently digging in his archive that the role he played in Belgian, as well as international, artistic and antimilitarist circles has come to light. It's time Albert Daenens gets his rightful place in Belgian and political art history. ⑤

1 After a rather short anarchist period, Paul Ruscart (1893–1946?) became a contributor to the pro-German journal *La Belgique*, and from 1940 to 1944 he worked for the collaborationist journal *Le Soir* and was editor in chief of the Nazi journal *Les Hommes au Travail*. At the end of the war he managed to escape and in 1946 he was sentenced in absentia to the death penalty. Abel Gerbaud (1888–1954) was a French painter with an interest in the applied arts, who met Daenens before World War I in Brussels where he was avoiding conscription. Léon De Roos was also an editor of *Le Revolté* in 1912. Later he would adhere to Flemish nationalism.

2 Archives of the City of Brussels, Archives of the Police, Bureau des Étrangers, dossier 76065: Rapport Mai 1913.

3 Maurice Casteels (1890–1962) was a Belgian writer who, before World War I, frequented anarchist circles. After the war, he aligned himself with the pacifist movement around Romain Rolland, which cost him his job for the city of Brussels. He wrote on art and architecture. In 1920, he co-organized a conference where Theo van Doesburg spoke, for the first time in Belgium, about his ideas on abstract art.

4 Charles Counhaye (1884–1971) was a multidisciplinary Belgian artist, who had contact with Romain Rolland, Philippe Soupault, and Henri Barbusse in Paris.

5 Depicted by Ary Delen, one of the members of the group, as follows: "Where once the altar stood, Steinlen's poster *L'Aurore* was hung, depicting a woman stretching longingly her arms toward the flaming dawn of the future. Right under it a long table with journals and magazines, such as *Van Nu & Straks*, *La Société Nouvelle*, and *Les Temps Nouveaux*." Cited in Stijn Vanclooster, Jan Moulaert, and Erwin Joos, *De Kapel tussen droom en daad. Anarchie en artistieke heropleving in Antwerpen rond 1900* (Antwerpen: VZW Eugeen Van Mieghem, 2013), 91.

6 Maurice Roelants (1895–1966), Flemish "psychological" writer.

7 Joos Florquin and Félix De Boeck, "Ten huize van . . . Félix De Boeck" in *Ten huize van . . .* ed. Joos Florquin (Leuven/Brugge: Davidsfonds/Orion-Desclé De Brouwer, 1971), 185–86.

8 "Notes et nouvelles," *L'art libre* 10 (1919): 112.

9 Sjoerd van Faassen, Hans Renders, and Erik Buelinckx, "'De stem uit de diepte': een onuitgegeven 'simultanéistisch spel' van Theo Van Doesburg," *Zacht Lawijd: Literair-historisch tijdschrift* 15, no. 3 (2016): 4–55.

10 Albert Daenens, *20 linos pamphletaires* (Bruxelles: Éditions du Repos Bien Mérité, 1929).

11 René Baert (1903–1945), Belgian writer and poet who in the 1930s became interested in Nazi mysticism and ended up as an adherent of Hitler. He was killed in Germany by Belgian soldiers at the end of the war.

12 Joos Florquin and Pol Jacquemyns, "Ten huize van . . . Pol Jacquemyns (1967)" in *Ten huize van . . .* ed. Joos Florquin (Leuven: Davidsfonds, 1980), 137.

2 KM.

SPECTACULAR COMMODITIES

GUY DEBORD AND THE SITUATIONIST INTERNATIONAL
AS CULTURAL ARTIFACTS

MEHDI M. EL HAJOUI

On June 15, 2009, two hundred or so art patrons enjoyed a luxurious gala dinner, hosted by the French National Library. The menu featured sea bass tartare with crisp garden vegetables, as well as exquisite vintage wines. Among the guests were Pierre Bergé, a noted bibliophile and cofounder of fashion label Yves Saint-Laurent; Nahed Ojjeh, widow of a Syrian-born arms dealer, as well as executives from the French petroleum multinational *Total*. Attendance at the exclusive event, which was held in the library's prestigious Hall des Globes, required a minimum contribution of five hundred Euro—two-thirds of which was tax-deductible.

But this wasn't your run-of-the-mill high-society dinner. Guests had gathered to support a fundraising campaign aimed at keeping Guy Debord's archives in France. Six months earlier, the French Ministry of Culture had designated the leader of the Situationist International a "National Treasure," preempting attempts by Yale's Beinecke Rare Book & Manuscript Library to acquire his archives for an estimated $2.5 million dollars. There was only one problem: Bruno Racine, the president of the French

National Library, had thirty months to raise an equivalent amount of money and make Alice Becker-Ho, Debord's widow, financially whole. And so, on that evening of June 15, the three spiral notebooks that comprise the original manuscript of *La société du spectacle* (The Society of the Spectacle)—Debord's opus magnum, his most celebrated attack against commodity society—lay open under protective glass, subjected to the gaze of wealthy benefactors in tuxedos and cocktail dresses. These men and women would play their part in preserving the legacy of one of the twentieth century's most important Marxist theorists and philosophers.

Archiving Debord and the Situationist International could be considered a duplicitous—dare I say a counterrevolutionary—effort. The movement and its leader explicitly rejected the curation of cultural artifacts, denouncing it as a reactionary bourgeois notion. Yet they also maintained an ambiguous relationship with their own material productions. Before shooting himself with a single bullet through the heart, Debord had meticulously organized his notes, letters, manuscripts, and other documents as if preparing them for the archive. This remarkable curation job partly explains the astonishing valuation of his archive.

I would like to unpack the complications inherent to Situationist artifacts and their archiving. Looking at a few iconic items, I'll explore how the European avant-garde movement created objects that simultaneously embrace and reject their own materiality. The pieces discussed here were part of the Situationist exhibit at the Lilly Library at Indiana University in Bloomington in February 2018.

Between 1958 and 1969, the Situationist International released twelve issues of an eponymous French language journal, *Internationale Situationniste*. The irregularly published bulletin served as the main vehicle to carry the organization's theoretical message, as well as its views on current events and society at large. Initially published in modest numbers, *Internationale Situationniste* saw its print run increase substantially as the avant garde movement gained visibility. As I will explain, the periodical embodies many of the contradictions inherent to Situationist artifacts.

Internationale Situationniste stood out among the more austere left-leaning publications of its time for a few reasons. First, the journal could be immediately identified by its trademark luxurious, glowing metallic cover. Debord took particular care in selecting the appropriate color for each issue, as evidenced in his correspondence. An important anecdote concerns the second issue of the journal, which was originally published in December 1958. The aluminum foil used for the silver cover was of poor quality and would peel off rather easily. Most copies started showing substantial damage to their wrappers, though the content remained unaffected. Yet the Situationists decided to rerelease the issue with a high-quality cover in the spring of 1962—the one and only time they would do so in the history of the journal. While the content

of the first and second printing are strictly identical, there are numerous differences in layout, particularly in the size of illustrations, the choice of upper and lowercase fonts in titles, and other typographical matters. Further, the Situationists took particular care in choosing the material on which their ideas were printed: *Internationale Situationniste* became associated with a thick, glossy paper stock. As one can imagine, all of this added to the cost of the publication, which was beyond the reach of working-class folks. This is something the Situationist René Vienet alluded to in the article "The Situationists and the New Forms of Action Against Politics and Art," published in *Internationale Situationniste* issue 11. I quote, "Let us spit in passing on those students who have become militants in the tiny would-be mass parties, who sometimes have the nerve to claim that the workers are incapable of reading *Internationale Situationniste*, that its paper is too slick to be put in their lunch bags, and that its price doesn't take into account their low standard of living."

The strict attention to typography and binding material makes it clear that *Internationale Situationniste* was concerned with its physical presentation. In doing so, it was no different from other avant-garde publications of the time. But Debord and the Situationists expressed disdain for collecting, which they viewed as a decadent expression of bourgeois materialism. *Internationale Situationniste* fought the collecting impulse by resisting notions of intellectual property and traditional authorship. Starting with issue 2, the journal contained an anticopyright notice: "All texts published in *Internationale Situationniste* may be reproduced, translated, or adapted without indication of origin." Piracy was encouraged to broaden the circulation of ideas beyond institutionalized distribution channels. The quintessential Situationist text *De la misère en milieu étudiant* (On the Poverty of Student Life) provides a suitable illustration. Originally published in 1966 using misappropriated funds from the University of Strasbourg's student union, the incendiary pamphlet has since been translated into a dozen languages. I have found over fifty pirate editions, published in France, the United

Union Nationale des Etudiants de France
Association Fédérative Générale des Etudiants de Strasbourg

DE LA MISERE EN MILIEU ETUDIANT

considérée
sous ses aspects économique, politique,
psychologique, sexuel et notamment
intellectuel
et de quelques moyens pour y remédier.

1966

Supplément spécial au Nº 16 de «21-27 Etudiants de France»

DE LA MISERE EN MILIEU ETUDIANT

considérée
sous ses aspects économique, politique,
psychologique, sexuel et notamment
intellectuel
et de quelques moyens pour y remédier

par des membres de l'Internationale Situationniste
et des étudiants de Strasbourg

1967

論大學生之貧乏

СИТУАЦИОНИСТСКИ
ИНТЕРНАЦИОНАЛ

О НИЩЕТЕ
СТУДЕНЧЕСКОЙ
ЖИЗНИ

**on the
poverty of
student life**

considered in its economic,
political, psychological,
sexual, and particularly
intellectual aspects,
and a modest proposal
for its remedy

by members of the
internationale situationniste
and students of strasbourg

**Da miséria
no meio estudan**

**& de alguns mei
para a preveni**

*Fenda, Edições
na cidade de Coimbra*

FREE

on
the
poverty
of
student
life

situationist international

ON THE POVERTY
OF
STUDENT LIFE

**situationist
international**

States, Portugal, China, Russia, and other countries, and it is likely that many more exist.

MÉMOIRES AND FIN DE COPENHAGUE

In its first five years, the Situationist International welcomed avant-garde artists to its ranks. The collaboration between Guy Debord, the "political" leader of the movement, and Asger Jorn, its most emblematic artist, led to stunning and politically charged creations. The French theoretician and the Danish visual artist collaborated on two artist books: *Fin de Copenhague* (End of Copenhagen), in 1957, and *Mémoires* (Memories) in 1958. In many ways, these works embody the Situationists' complicated relationship with their material productions.

Fin de Copenhague is a slim, unassuming volume. The book was allegedly printed within twenty-four hours (though art historians are now questioning this timeframe) as an artistic experiment. The story goes that, having just arrived in Copenhagen, Jorn and Debord stole a huge amount of newspapers, and then spent a drunken afternoon cutting up and putting elements back together. The next day they arrived at the printer with thirty-two collages, which were transferred to lithographic plates. Jorn sat at the top of a ladder and dropped cup after cup of India ink onto the zinc plates, creating the result seen on the page. Quoting art critic Rick Poynor, "Abstract shapes, like the frenetic daubings of a monkey wielding a paintbrush, were printed on both sides of the sheet in gradated color, and the collage elements were printed in black on top of them. When the sheet was trimmed and bound, the formerly continuous marks and colors of Jorn's carrying structure produced random collisions of color and shape on the spreads. Pure chance completed the design."

To some degree, *Mémoires* and *Fin de Copenhague* were conceived and executed as traditional, high-end artist books. The former was released in an edition of five hundred, while only two hundred numbered and signed copies of the latter were produced. Permild & Rosengreen—the famed Danish printer of COBRA and the

Dix minutes après, l'émotion étant
dissipée, on buvait le champagne

There's no whiteness

VIVE
L'ALGÉRIE
LIBRE

Beaucoup de militaires conseillent les djebels pour
guérir rapidement « la difficulté d'être »

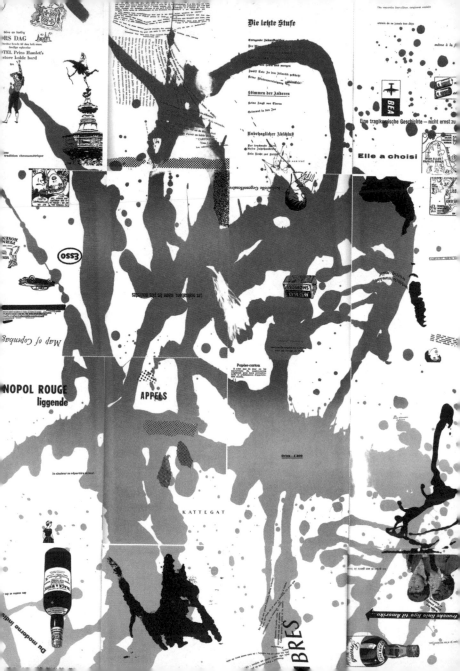

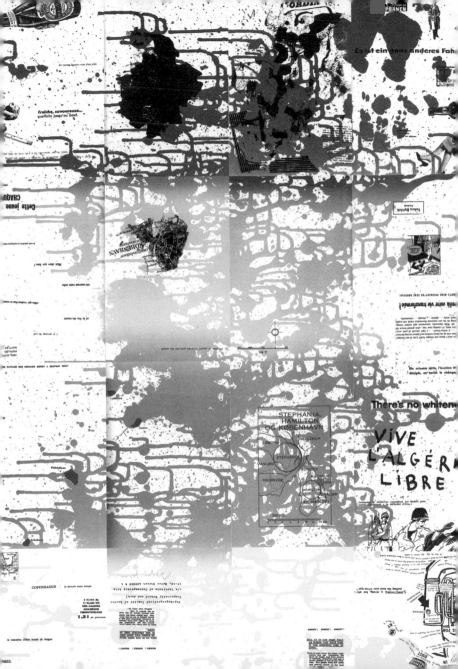

Scandinavian avant-garde—published and marketed the luxurious, limited-edition volumes. Though Debord had initially rejected its commercialization, *Mémoires* was ultimately sold to collectors as its author sought to—and quoting from his correspondence—"sell his prestige and recoup his losses with suitable liquid compensations." Meanwhile, a copy of *Fin de Copenhague* fetched an eye-popping $14,427 when it hit the auction block in 2011. From what it seems, then, Debord and Jorn's endeavors were no different than, say, those of Diether Roth, Yves Klein, or Marcel Broodthaers. Or were they?

Fin de Copenhague and *Mémoires* also paradoxically reject their own status as aesthetic creations. While they are artist books, they are also political works—declarations of war against the society of the spectacle. *Mémoires* is best known for its bold, unique wrappers: a single sheet of heavy grade sandpaper. The intent was that the book would cause damage to the books next to it on a library shelf. On an alternative cover, the traditional sandpaper cover has been substituted with a sheet of black, plastic-like paper unto which 110 razor blades have been latched. In each case, the destructive aim is clear. *Fin de Copenhague*'s blue-gray publisher bindings, on the other hand, are made of flong—a byproduct of the newspaper printing process that would generally have been discarded—and each copy is unique.

Let's now focus on the contents of the books. For *Fin de Copenhague*, the artists used scraps from Danish newspaper *Politiken*. This gesture should be interpreted as a way to protest the views contained in the publication—Debord and Jorn viewed the articles and advertisements published by the conservative daily as a kind of cultural garbage. By taking these elements out of context, the Situationists exposed their alienated dimension while giving them a newfound authenticity. This is a prime example of the Situationist concept and technique known as *détournement*, which translates roughly as "hijacking." The notion was first defined in the inaugural issue of *Internationale Situationniste* as "the integration of present or past productions into a superior construction of a milieu. . . . Within the old cultural spheres, [it] is a method of propaganda, a method which reveals the wearing

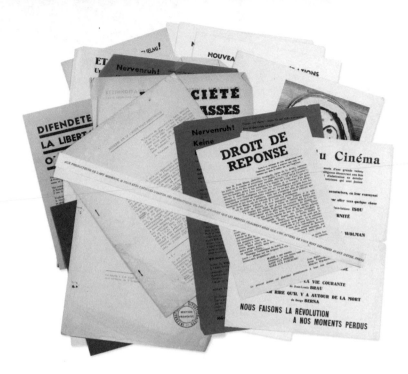

out and loss of importance of those spheres." Détournement, then, is one way for Situationist artifacts to exist as both heralds and opponents of high culture, positive and negative commodities at once.

LEAFLETS

To wrap up, I would like to call your attention to a favored material form of cultural and political expression among Debord and the Situationists: leaflets. The movement produced around a hundred of them, including both handbills and slightly larger broadsides, in its fifteen-year history.

On the one hand, leaflets are the ultimate anticommodity. They are ephemeral—often printed on brittle, low-quality paper, they are meant to be neither preserved nor collected. Further, their mode of circulation trumps traditional commercial channels. Leaflets are rarely sold; instead, they are given away, most often in a public setting—for instance, a demonstration. Because they seek

LE RETOUR DE LA COLONNE DURUTTI

ASSOCIATION FEDERATIVE GENERALE DES"ETUDIANTS" DE STRASBOURG

Octobre 1966

to communicate a message as broadly as possible, they are printed in large numbers. Finally, limited thought may be given to design or typography.

Situationist leaflets are a bit different, however. Let's take two examples: *Le retour de la colonne Durutti* (The Return of the Durutti Column) from 1966 and *Aux producteurs de l'art moderne* (To the Producers of Modern Art) from 1958. The former is a four-page comic by André Bertrand, a student and close affiliate of the Situationists. Given away at the University of Strasbourg during a student protest, it was inspired by the life and deeds of anarchist Buenaventura Durutti, who fought against Franco during the Spanish Civil War. This item is remarkable in many ways. First, it stands out due to its unusual size—14.5 x 9.5". This would have surely made it more expensive to print, as nonstandard-sized paper would have been required. *The Return of the Durutti Column* is also heavily illustrated and showcases a good amount of typographic

creativity. Overall, it is a remarkable production that has inspired many. Contemporary Welsh artist Cerith Wyn Evans, for instance, adapted a frame from *The Return of the Durutti Column* to create his 1997 screenprint entitled The Return of the Return of the Durutti Column (now part of the permanent collection of the Tate Museum).

Let's now shift our attention to *Aux Producteurs de l'Art Moderne*. This phenomenal tract consists of a single thin and long strip of paper (about 0.75 x 35") that comprises a single sentence. It reads as follows, "If you are tired of copying the demolitions; if you think that the fragmentary repetitions expected of you are outdated before they even come about, contact us to organize the new powers for a superior transformation of the surrounding environment." Like *Mémoires* or *Fin de Copenhague*, this item speaks to us through both its form and its content. Sure, I can copy the text on an 8.5 x 11" piece of paper, but it won't have the same effect—and ultimately, this is why materiality matters.

CONCLUSION

Debord insisted that his works be made available to all—as you may recall, he didn't believe in copyright. Today, all of his writings can be found on the web at no charge—including a PDF version of the artist book *Mémoires*. Yet there is something uniquely compelling about the abrasive sandpaper cover—it amplifies the message contained in the book, screams out to the reader, "I AM DANGEROUS. I AM HERE TO DESTROY WHAT YOU KNOW." This physical item, like the other artifacts discussed here, speaks volumes. Situationist objects, it appears, have no way of escaping their materiality. What is most remarkable to me, though, is that they use this materiality to challenge traditional taxonomies—for instance, artist book vs. political manifesto—and create a dialectical relationship between form and content. Oh and just so you know, the French National Library did raise the money, and Debord's archive is now locked away in a secure room. **S**

A Red Star and Four Red Stripes

Fifty Years of Catalan Independence Movement Graphics, 1969–2019

by Jordi Padró

In 1997, Carles Fontserè, a renowned Republican cartoonist and poster designer of the Spanish Civil War, was asked to make a poster for a local pro-independence group in Banyoles, Catalonia. Although Fontserè was retired and no longer accepting commissions, the young activists were able to convince him to design a poster, not because they offered him money, but because they were asking for his commitment—a commitment he had assumed designing revolutionary billboards during the Spanish Civil War. The result is the image of the grim reaper as worker, marching in front of the four bars of the Catalan flag, with a red star waving in the sky. Above the image are the words: "1707–1997, 290 years of Spanish Occupation." This image is an update of his famous poster made for the anarchist labor union, the CNT-FAI, in 1936 which was previously inscribed with the word "freedom." The graphics of the past fifty years of the Catalan left independence movement have their roots in the imagery produced in Catalonia during the Civil War and from there have grown into vivid expressions of the desire for independence made by the most militant tendencies.

Although this movement is currently celebrating its fifty-year anniversary, much of its history and graphic output have been formed by its young people, due to the dynamics of the movement and its experience of splits and conflicts within its organizations. Both the movement's youthfulness and conflictual nature are embedded in the graphics, which are infused with dynamism, combativeness, and the aesthetics of militant youth culture.

Here I present an overview of the graphic history of this period of the Catalan leftist separatist movement. This essay is based on conversations with a dozen designers from many different organizations, taking into account the plurality of the movement.

1707 – 1997
290 anys d'opressió espanyola

dissabte 5 d'abril de 1997
a Banyoles

organitza
CASAL INDEPENDENTISTA DE BANYOLES

PP.CC PRODUCCIONS

DIADA REIVINDICATIVA
cercavila - mural - dinar - xerrada

22h. **concert**
al Local Can Carreras
(MATA - PORQUERES)
preu: 1.000 ptes. Ctra. Banyoles - Girona

MARTO'S PIKEURS (Narbonne)
KARGOL'S (Catalunya Nord)
OBRINT PAS (País Valencià)
POTATO (Euskal-Herria)

Casal independentista de Banyoles (illustration: Carles Fontserè), 1707–1997, 290 years of Spanish Occupation, 1997.

Clockwise from top left: *Lluita*, issue one, 1969; AMEI, etc.,
*Stop Torture/Free Independence Prisoners/In Prison There Is
No Christmas*, 1992; CSPC, *Freedom/Justice for Terra Lliure*,
1982; PSAN, *The Social Pact Maintains Capital/Let's Fight
Unemployment and Repression!*, 1980; Comitès de Solidaritat amb
els Patriotes Catalans, etc., *At Fossar!/11th of September* [Where
the defenders of the city of Barcelona of 1714 are buried/Catalan
National Day—the day of the defeat of Barcelona in 1714], 1980.

1969–1976: Clandestinity (The Symbols Are Born)

The dictatorship of Francisco Franco emerged in 1939 out of
the defeat of the Left in the Spanish Civil War. His rule lasted for
thirty-six years and was marked by severe repression, which forced
much of the movement to work underground until his death in 1975
(with many organizations classified as illegal until 1977).

One of the early groups was the Front Nacional de Catalunya
(National Front of Catalonia, FNC), a nationalist party founded
in 1940 from exile in Paris. In the late 1960s, younger FNC activ-
ists, influenced by the French uprisings and strikes of May 1968
and by the anti-colonial and anti-imperialist struggles around the
world, split from the FNC and in 1969 created the Partit Socialista
d'Alliberament Nacional dels Països Catalans (Socialist Party for the
National Liberation of the Catalan Countries, PSAN) as a Catalan
independentist and revolutionary party with a Marxist orienta-
tion. This is considered to be the beginning of the Left Catalonian
Independence movement.

The early graphic work of the movement is scarce, and what
does exist was most often produced by a variety of homemade printing
machines such as mimeograph, gestetner, clandestine printshops, or
even just by hand painting. The imagery and style are inspired by
similar revolutionary movements of the time, especially the Basque
national liberation movement, with which PSAN maintained a
relationship. This early work is when the core symbols of popular
separatism were established. For example, in August 1969, in the
first issue of PSAN's magazine *Lluita* (Fight), the red star, the map
of Catalan Countries, and the slogan "Socialism, Independence"
already appear.

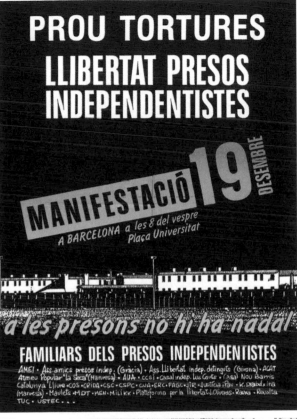
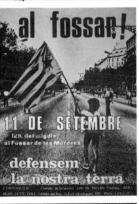
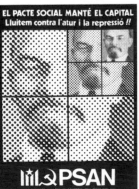
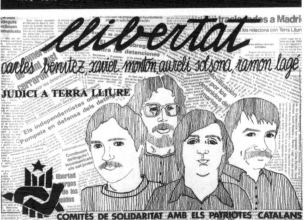

In the 1970s, the PSAN underwent several ruptures. In 1974 the PSAN-Provisional splits from the larger group, and in 1979 it renames itself the Independentistes dels Països Catalans (Independistas of the Catalan Countries, IPC). In 1977, another split from PSAN created the Moviment d'Unificació Marxista (Marxist Unification Movement, MUM) and in 1980 another splinter integrated with the Nacionalistes d'Esquerra (Left Nationalists, NE). All of these fractures led to the left independence movement losing focus and heft, and by 1980 they became quite marginal politically. The different left electoral lists failed to gain seats in either the Catalan Parliament or the Spanish Congress and only a few representatives were elected to city councils.

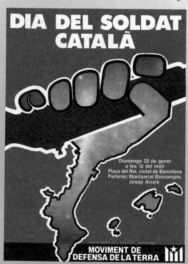

In 1979 there emerged both the armed organization Terra Lliure (Free Land) and the anti-repression organization Comitès de Solidaritat amb els Patriotes Catalans (Solidarity Committees with the Catalan Patriots, CSPC). Criminalization of the movement intensifies. In response, a wing of the movement attempted to present a more friendly and inclusive public image. The main purpose was to counteract the dominant narrative presented by the police and the state: images of activists as terrorists, images of prisoners taken in harsh lighting, images of violence, and reprisals. These representations blurred the differences and politics of the independence factions, attempting to generate suspicion and

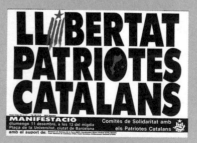

create a broad rejection of independence politics. As Isabel Herrero explains, it was proposed that the movement create its own popularly accessible aesthetics. These would clearly differentiate it from the rest of the political landscape and could be reproduced in nonprofessional print media. The movement spread more approachable representations of prisoners through drawings of their faces, began to use more handwritten typography, and designed with clear and bright colors in order to generate more empathy among the population.

With little financing other than contributions from activists in the movement, putting up posters on the streets was one of the few means the nonparliamentary Left had to publicly spread their ideas and political campaigns. This is the reason the agitprop of the left independence movement was politically crucial during this period—the idea blossomed in part because strolling through streets throughout Catalonia, one would be surrounded by posters, stickers, paintings, and banners from left independence organizations.

We also have to look at the case of Nacionalistes d'Esquerra (Left Nationalists, NE), which in 1980 decided to participate in the electoral political process and hired a professional design firm, Encaix, to generate its graphic representation and brand. They created a professional image that diverged from the history of movement design, but also sought to visually connect NE to the tradition of left independence. The result was an innovative logo consisting of a diagonal band containing the name of the organization and a star with unequal points, which made for a very dynamic emblem.

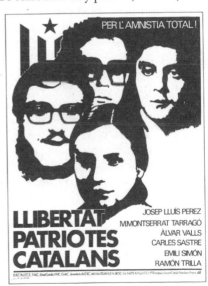

Above: various organizations, *Freedom for Catalan Patriots*, 1977; opposite, top: MDT [a PSAN fraction] (design: Felix Bella—inspired by an OSPAAAL poster designed by Asela M. Pérez), *Catalan Soldier Day*, 1988; bottom: MDT (design: Fèlix Bella), *Freedom for Catalan Patriots*, 1989.

Clockwise from top left: MDT (design: Fèlix Bella), *Defend Catalan [the language]/ Regain Independence/Catalans Don't Have or Want a King*, 1988; Ateneu Popular l'Estel (illustration: David Parcerisa), *Refuse It!/Kill the Heroin Before It Kills You!*, 1993; Grup de Defensa de la Terra del Maresme, *We Defend Our Land*, 1983.

1983–1988: The Time of Black Scarves

Between 1983 and 1986, the pro-independence movement went through a period of rapid growth, with a new militancy nourished by youth who had not lived under the terror of the Franco regime.

In 1984, after a couple of years of development, Moviment de Defensa de la Terra (the Movement for the Defense of the Land, MDT) emerged as a united front organization of the pro-independence left. With the MDT, a new representation of the movement was created and transmitted by more embodied activist tactics. A combative graphic sense reigns, where blacks, whites, and reds predominate. This new imagery is exported to the streets via banners that lead demonstrations and iconic black scarves, which many young people wear around their necks during actions. These scarves double as tools to cover faces, as rioting is endemic in this period of demonstrations.

One of the artists that worked with the MDT is the cartoonist David Parcerisa a.k.a. El Gat (the Cat), who says that he tried to give his designs their own personality. He was influenced more by the Central European squatter graphics of the 1980s or by May '68 graphics, than the imagery of the Basque movement or the Soviet Union which had previously dominated the aesthetic discourse.

For the first time, the material of the broader left independentista was primarily being produced by professional printing companies that were unrelated to the movement. But due to the militant tenor of the MDT, a dedicated, movement-oriented screenprint shop was set up in Barcelona by Ramon Subirats. It produced much of the MDT's material, including posters, stickers, shirts, and the aforementioned black scarves. The MDT and other antiparliamentarian elements were severely underfunded and were mostly volunteer-run. This meant they had to be creative in order to generate and distribute mass amounts of agitprop. An anecdote from this period recounts how MDT militants got hired by other political parties to hang election posters and instead took large amounts of these posters and printed their own campaigns on the back sides.

Compared with the other graphics of the period, these are

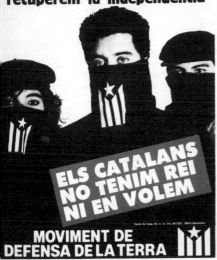

ABRIL-88
**defensem el català
recuperem la independència**

ELS CATALANS
NO TENIM REI
NI EN VOLEM

**MOVIMENT DE
DEFENSA DE LA TERRA**

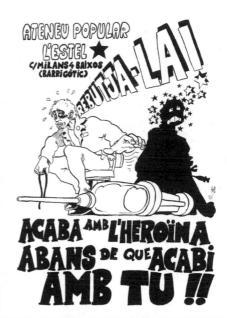

ATENEU POPULAR
L'ESTEL ★
C/MILANS 4 BAIXOS
(BARRI GÒTIC)

REBUTJA-LA!

ACABA AMB L'HEROÏNA
ABANS DE QUE ACABI
AMB TU!!

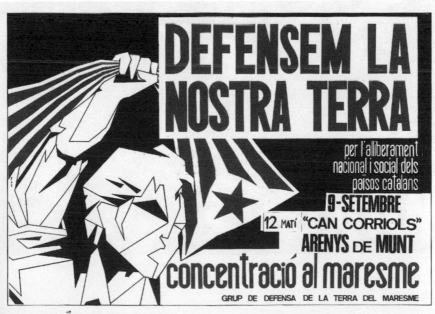

DEFENSEM LA
NOSTRA TERRA

per l'alliberament
nacional i social dels
països catalans

9-SETEMBRE

12 MATÍ "CAN CORRIOLS"

ARENYS DE MUNT

concentració al maresme

GRUP DE DEFENSA DE LA TERRA DEL MARESME

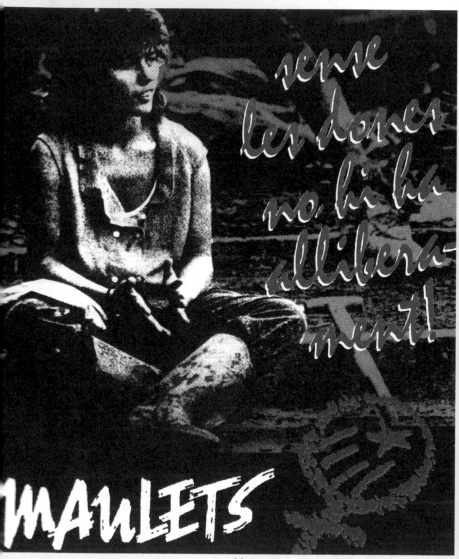

sense
les dones
no hi ha
allibera-
ment!

MAULETS

Maulets, *Without Women There Is No Liberation*, 1995.

obviously hand crafted and project a raw immediacy. The Spanish police raided their silkscreen studio and seized their equipment during a series of arrests in 1992. Thanks to a large donation from the Subirats family, thousands of the posters and placards that survived are now archived at the Documentation Center of the Independentist Left (CDEI).

In 1987, the MDT went through a crisis that led the group to split into two organizations. Both splinter groups retained the name and maintained the same graphic presentation, which made it difficult to identify which was which. The tension within the movement, especially around whether to follow a course of armed activity (Terra Lliure's vanguard approach) or to instead take root among the working class, widened the gulf between approachable and militant aesthetics. This is especially the case with those factions that idealized armed conflict, who created designs that built a mythic-level resistance aesthetic: black scarves covered faces, arms raised rifles, and tributes were made to the fighters and prisoners.

At the end of 1987, the two MDT factions further split. First the youth organization Maulets was born out of one of the groups and then in 1989, the electoral platform Catalunya Lliure was created (which eventually became its own independent political organization). The other faction maintained the name the Moviment de Defensa de la Terra (MDT), and in 1990 created the Joventuts Independentistes Revolucionàries (Independent Revolutionary Youth, JIR) organization, and in 1993 helped spearhead the Assemblea d'Unitat Popular (People's Unity Assembly, AUP).

1989–1995: Color against Repression

After the breakup of the MDT, the two factions both tried to offer a new image of left independence, which is clearly represented in their graphics. The main stylistic evolution was an explosion of color, similar to the one that had been taking place in the Basque Country. This turn to fresh and bright designs developed out of a need to convey messages more positively.

In 1992, the Olympics descended on Barcelona. Protests against the games led to the arrest of forty-five independentist

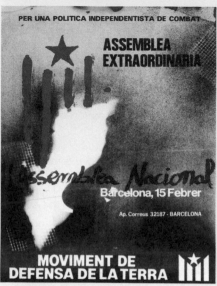

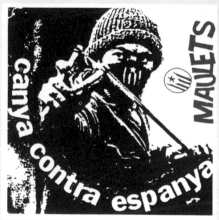

Clockwise from top left: MDT [an IPC faction] (design: Marcel Dalmau), *For a Militant Pro-Independence Policy/ National Assembly*, 1987; PUA (design: Lluís Bartra), *Homage to Toni Villaescusa* [Terra Lliure militant killed in action], 1996; Ateneu Popular la Seca (design: Edu Fíguls), *By All Means Necessary/To Resist Is to Win* [pro-squatting concert poster], 1996; Maulets, *Fight against Spain* [iconic design inspired in a photograph of Santos Cirilo from a labor strike in Euskadi], 1989.

militants, many of them reported to have been tortured by the Spanish police, with seventeen eventually sentenced to prison. This left the movement very weak politically, with most of its focus and energy placed on prisoner defense.

The following years saw a continued decline of the militant wing of the movement, with many from the various left independence organizations joining the center-left party Esquerra Republicana de Catalunya (Republican Left of Catalonia, ERC). A further blow came in 1995, when Terra Lliure dissolved. These developments forced the movement into a new stage, with young people once again taking the lead. While the rest of the movement was shrinking, youth organizations grew and developed left independence *casals populars* (community centers) where political groups could meet, organize, and socialize. Currently there are more than one hundred casals populars in Catalonia.

The first popular youth festivities were also started, direct, politicized alternatives to less radical counterparts organized by town councils. The artist Eduard Fíguls created several posters for the Alternative Festival of Manresa. He remembers that for these festivals he was given much more creative freedom than when doing work directly for political organizations. In general, the illustrations for the festivals were usually created by local designers and cartoonists.

1996–2002: Youth in Struggle

By the mid-1990s, youth culture became a dominant aspect of left independents. An alternative community tightly linked to punk and hardcore music developed, with ideologically driven musicians and fanzines effectively politicizing the "scene." Music subcultures became a meeting point between independentistas and anarchists. Bands such as Inadaptats, Opció K-95, and Kop released records with covers featuring masked figures, guns, and protests, which were an extension of their lyrics and became some of the dominant graphics of the period. Young people in large numbers throughout Catalonia joined local political groupings and brought the punk aesthetic into the movement. The images circulated not only on record covers but also on T-shirts, posters, flyers, stickers, and zines. Most

EL JOVENT UNIT en lluita!

[uneix-te]

**Maulets som
una organització
independentista
revolucionària de
joves que lluitem per
uns Països Catalans
independents,
sense classes,
no-sexistes i
ecològics...**

Mallorca: Apartat 14 - C.P. 07000 - Ciutat
València: Tel 618970402 Apartat 61 - C.P.46080
Barcelona: Apartat 2671 - C.P. 08080
Internet: http://www.pangea.org/org/maulets
Correu electrònic: maulets@pangea.org
Seu Nacional: Tel. i fax 937 55 19 15 - Carrer Nou, 11 Baix - C.P. 08301 Mataró.

MAULETS
el jovent independentista revolucionari

19 de JULIOL
1936 // 2016

80 anys DE LA Revolució

CAMPEROLS LA TERRA ES VOSTRA

ENCARA QUE LA TARDOR DE LA HISTÒRIA
COBREIXI LES VOSTRES TOMBES AMB L'APARENT POLS DE L'OBLIT,
MAI RENUNCIAREM NI AL MÉS VELL DELS NOSTRES SOMNIS.

MIGUEL HERNÁNDEZ

★cup

Contra la globalització
Defensem la Terra
Independència revolució

MAULETS

8 de Març: Dia de la dona treballadora #VagaFeminista

8 de març
totes a la vaga!
Aturem-nos!

ASSEMBLEES DE
JOVES
per la unitat popular

Guanyem
UN FUTUR
FEMINISTA

@poblelliure_ppcc @laforja_jovent

CAPGIREM EL MODEL DE CIUTAT

CRIDA
PER PALMA

**VOTA
CRIDA
PER
PALMA**

#RECUPEREMPALMA

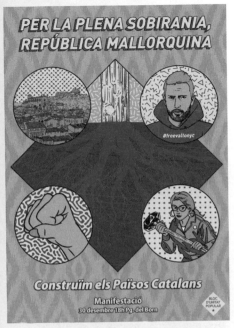

PER LA PLENA SOBIRANIA, REPÚBLICA MALLORQUINA

#freevaltonyc

Construïm els Països Catalans

Manifestació
30 desembre 18h Pg. del Born

BLOC D'UNITAT POPULAR

CREMA EL PATRIARCAT!

25N DIA INTERNACIONAL CONTRA LA VIOLÈNCIA MASCLISTA

of the designs were illustrated by hand or collaged manually, with little graphic finesse, which distilled into a militant aesthetic with great agitational power.

It is in this context that the Plataforma per la Unitat d'Acció (Platform for the Unity of Action, PUA) emerged in 1995. As explained by Lluís Bartra, one of the PUA's main designers, "the forcefulness of the message, without censorship . . . this was the organization that we created, a breath of fresh air, and this was impregnating the graphics of those times." This was another moment of aesthetic shift, due to the emergence of the computer as a tool for graphic design. Desktop publishing facilitated broader participation in the movement's

design by making it more accessible to a broader range of young militants with computer skills.

Although this was a militant period, with actions against exploitive temporary employment companies, against the Partido Popular headquarters (a pro-Spanish right-wing party), and continued street activism, it was also a stage of organizational growth. In 1998, the youth organizations Maulets and Joventuts Independentistes Revolucionàries (Revolutionary Independentist Youth, JIR) merged. In 1999, the La Coordinadora d'Estudiants dels Països Catalans (CEPC) emerged from the convergence of various student unions, in 2000 the PUA transformed itself into Endavant (Forward), and in 2001, the antirepression organization Alerta Solidaria was created.

Vicent Chanzá and David Segarra, two designers from Valencia, made their contribution by shaping the graphic identities of both *Maulets* and *Joventuts Independentistes Revolucionàries*. The *Maulets* imagery continues to be an important influence for movement designers. These images included new references from the world

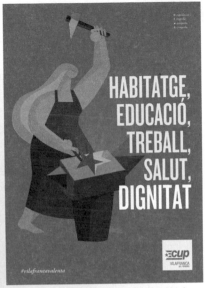

Opposite: CUP (design: Joan Jubany), *Identity Manual for Local Assemblies*, 2010. Above left: CUP Vilafranca del Penedès (illustration: Muntsa González, design: Jordi Padró), *The People Rule, the Government Obeys*, 2019; right: CUP Vilafranca del Penedès (illustration: Muntsa González, design: Jordi Padró), *Housing, Education, Work, Health, Dignity*, 2019.

of graffiti, Zapatismo, the antiglobalization movement, the rural world, and promoted the return to "the roots" of the Independence Movement by using Iberian iconography and reintroducing iconic designers such as Josep Renau, the Valencian poster artist from the Spanish Civil War. They created a more branded look, defining the youth organization in a singular shade of orange, a color that was not being actively used by any other organization but referenced the colors that had been used historically by the movement (with the merging of red and yellow). The look they created was much more corporate in style, and felt risky at the time because it was initially not understood by those more entrenched in the DIY, street-level design previously so popular in the movement.

2003–2010: Opening of the movement

In 2003, major changes took place, as candidates connected to the Municipal Assembly of the Independentist Left (later

Candidatura d'Unitat Popular, CUP) won about twenty seats in various city councils. These positive electoral results led many local groups to put forward municipal candidates for the following elections. The designs for these elections adapted to these new circumstances, and a growing need to communicate in a visual language more accessible to the majority of the population was explored. According to designer Diego Muñoz, a.k.a. MilVietnams, "we needed to leave the grunge aesthetic [behind] and prioritize clear messages that synthesized the movement's politics." To this end, at the end of 2010 Joan Jubany created an identity manual for the CUP—which clearly shows this professionalization of the movement's aesthetics.

Several projects arose, like the Documentation Center of the Independentist Left (CDEI) in 2003, which is dedicated to collecting, archiving, and digitizing historical materials of the movement. It was initially created out of necessity: many people retained ephemera from organizations that no longer existed, and it was necessary to find a place to archive these materials. Beyond simple preservation, CDEI aims to be a point where historians and interested people can access these documents. At present, there are thousands of posters, leaflets, stickers, publications, and other materials available. In 2016, a similar initiative appeared, the FDEIP, or Fons de Documentació de l'Esquerra Independentista a les comarques de Ponent (Documentary Fund of the West Independentist Left), that focuses its activity on compiling materials produced by groups of the movement in the counties of Lleida.

2011–Now: The Way to Independence

In 2012, Arran appeared, a youth organization born from the union of Maulets and the Coordinadora d'Assemblees de Joves de l'Esquerra Independentista (the Coordinator of Assemblies of the Youth Independentist Left). Carles Duran, one of those responsible for Arran's designs, says, "We collaborated to design something new, more open, and appealing to the experience of the youth." He emphasizes: "We cannot remove the political from the graphic. It is the visual and aesthetic representation of a conflict, of a political narrative, and it must be understood as such."

Above left: illustration by Víctor Malafolla; right: Endavant (design: Malafolla), *They Call It Democracy—It's Not!*, 2018.

Also in 2012 we see the CUP make the leap into electoral politics, and win three deputy seats in the Parliament of Catalonia. Within Catalonia at this time there is growing support for independence, in large part in response to the Spanish government's mismanagement of self-governance initiatives. This confrontation with Spain provoked a 2014 consultation of self-determination and then October 1, 2017's referendum on independence.

Graphic design played a large and visible role in the lead up to the referendum, with an explosion of posters, stickers, and leaflets being produced, and the Spanish police seizing materials from various printers. On September 20, 2017, the police tried to enter CUP headquarters illegally, with the intention of stealing campaign materials, but a gathering of militants prevented their entry and then distributed the materials across multiple locations so they couldn't be confiscated.

The referendum was carried out with 43 percent participation and 90 percent affirmative votes. The declaration of independence of Catalonia, on October 27, 2017, provoked an extreme response from the Spanish state, with some of the independence leaders jailed and

others forced into exile. One of those still in exile is Anna Gabriel i Sabaté, a leader of the CUP.

Now we start a new phase for the pro-independence movement, which will have to strategize how to face the novel challenges ahead. It is clear that this work will also have to be reflected in the movement's design. Víctor Dorada and Mar Balaguer, from the graphic group Malafolla of Palma (in Mallorca), believe that their work should "bring the public closer to the movement through a more attractive graphic line and a style more in tune with the tendencies of each moment, without losing the message on the way, but enhancing it and bringing it to a wider audience . . . adapting it to the personal style." A personal style that includes ideas from street art, comics, and the tradition of revolutionary political posters from all over the world, not just Catalonia. Graphic designer Diego Muñoz believes that the primary design need for the present, and into the future, is to "dignify the work and the creative freedom of both graphic designers and illustrators within the movement, making effective arguments about the importance of this work for independence." Ⓢ

Bibliography

Bassa, David. "Independentisme al Vallès Oriental." *l'Anuari del Centre d'Estudis de Granollers*. 2009.

Buch, Roger. "El Partit Socialista d'Alliberament Nacional dels Països Catalans (PSAN) (1969–1980)." Doctoral thesis, Universitat Autònoma de Barcelona, 2010.

Cabedo, P. (Roger Ferriols). *Tornarem a lluitar!*. 2006.

CEPC, 5 anys en marxa. Construint alternatives des de les aules. PPCC, Edicions CEPC.

Independència (magazine), no. 5, 1991.

Jordi Pardó, Martí Puig, and Pep Garcia, eds, *Difon la idea: Memòria gràfica de l'Esquerra Independentista (Adhesius 1969-2019)*. Pol·len Edicions, 2021.

Francesc Poblet i Feijoo, et al. *Nacionalistes d'Esquerra 1979–1984*. Fundació Josep Irla, 2004.

Precedents de la CEPC, 25 anys de lluita estudiantil. PPCC, Edicions CEPC.

https//:llibertat.cat/2008/07/la-memoria-independentista-ramon-subirats-i-coral-4364.

https//:llibertat.cat/2015/09/1979-1987.-aportacio-a-la-imatge-grafica-de-l-independentisme-32358.

Images

Martí Puig (stickers)

Centre de Documentació de l'Esquerra Independentista (CDEI).

Blog of designer Joan Jubany, https://joan7.jubany.cat/galeries-de-disseny/.

**KAHLED
&
LENIN**

**GOLDMANN
&
CASTRO**

**KOLLONTAI
&
FUSTER**

**BEAUVOIR
&
HO CHI MINH**

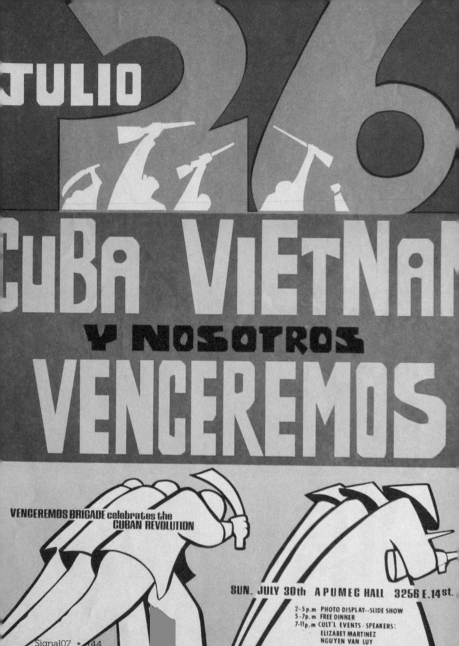

JULIO 26

CUBA VIETNAM
Y NOSOTROS
VENCEREMOS

VENCEREMOS BRIGADE celebrates the
CUBAN REVOLUTION

SUN., JULY 30th A PUMEC HALL 3256 E. 14 st.

2–5 p.m PHOTO DISPLAY--SLIDE SHOW
5–7p.m FREE DINNER
7–11p.m CULT'L EVENTS · SPEAKERS:
ELIZABET MARTINEZ
NGUYEN VAN LUY

P.o.box 4705 S.F. 94101

Signal07 ★ 144

MALAQUÍAS

Interviewed by Bill Berkowitz

Malaquías Montoya grew up laboring in the fields of the Central Valley, California, and worked in the agricultural industry alongside his mother and siblings. Only after the harvest was in was he able to go to school. Montoya was placed in special education with mostly Mexican American and African American students—math, science, history, and English were rarely taught. It was in this environment that Montoya first began to draw. Thus began a lifelong journey for an artist who has been at the forefront of the struggle for social justice for nearly fifty years.

Montoya's political paintings, screenprints, and murals have always served the underrepresented, the neglected, and the oppressed. Over the years, his work has helped social justice organizations, community spaces, and movement printshops highlight struggles for immigrant rights, worker's rights, women's rights; and the fight against racism, war, and US imperialism.

Now in his eighties, Montoya is a University of California, Davis, professor emeritus of Chicano studies and art. He has been a key figure in the revival of political screenprinting in the left, an essential participant in the Chicano arts movement, and at the forefront of the civil rights struggle for Mexican Americans since the 1960s. He remains an active creator of graphics, murals, and art for social movements and continues to be a mentor and teacher for younger generations of politically informed artists.

MONTOYA

Art historian Lincoln Cushing has said that "Montoya is one of the movement soldiers who's kept the flame of social justice art alive. He consistently ignored the path of art world fame in favor of community impact and principled politics."

During a visit to the show *Women I Have Encountered/Mujeres Que He Encontrado*—a collection of female-centered images produced by Montoya at the Vacaville Museum in California, I had the privilege of interviewing Montoya about his life, work, and social activism.

First off, I want to get your reaction to a recent story out of San Jose, California. The "Mural de la Raza," painted in 1985 by Jose Mesa Velasquez and depicting Chicano history, was painted over in the middle of the night, apparently by property developers. As a muralist, what is your reaction to that incident?

Well, I'm always disappointed to hear that a mural has been painted over or done away with. I know Jose Mesa Velasquez very well. I knew him in Oakland, and he came up and gave a lecture in my class Survey of Chicano Art at UC Davis. It's troublesome because the destruction is of a piece of artwork that means so much to that community. It's like telling someone, "You don't matter." In the early 1970s I had a mural on Market Street as you come into San Jose, on the side of a law building. The space was very narrow, only about eight feet high, but it was one hundred feet long, so when you came over the hill from the Santa Clara side, it would just appear. It was really quite striking. When people would come in from out of town, it was a nice drive to go to San Jose to show them something I had done, and to go over the hill, especially if you picked the right time, as the sun was setting, the colors, like the reds and yellows, going down with the sun, would hit the wall, it would just light it up.

What was the mural?

It was a central figure sitting on a chair coming forward. In one hand they had a law book, and in the other hand something

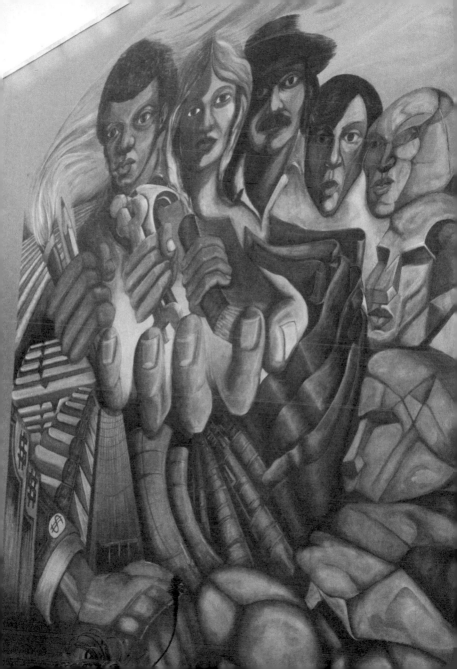

else, and then on the two sides you had blackberries, crouching in front of mountains, coming forward. On the other side Mexican revolutionaries were coming forward in the same way. Once, I took friends from the East Coast, and I took them over to show them, and it was gone; it was a white wall. And this was the first I knew about it, so I contacted the person who had first contacted me, and he was like, "Oh, Malaquías, I'm sorry it's gone, but the new owner just didn't want the mural and they did away with it." I guess he had every right, I don't know how that works, he can just say now it's my building and I don't want a mural or any painting on my wall.

And I just got an email from someone over in Clinton Park, and there's a mural there that I did with some of my students, in the early '70s, in Oakland, down by the lake near the Escuelita school, and when that burned they had to take the wall down, because there wasn't much left of it. But he invited me to come and do more murals.

When the Velasquez mural got painted over, it seemed like an attack on the community and the erasure of history, and the community was pretty angry.

Yes. In my case, nothing happened. I realized that before then I hadn't—at that time I was just starting to do murals—and I hadn't realized the importance of contacting the community around you, to get your ideas out, and hear the ideas they have, to have input from that community, so that it belongs to them. So then when someone wants to destroy something, they have to deal with that community.

I think one of the wonderful things about murals is that when you bring people in around them, it becomes an organizing tool that can bring people together and they can claim them as theirs.

Your current exhibit is *Women I Have Encountered/Mujeres Que He Encontrado*. Who are these women, and why the focus now?

These women are women that I have encountered, maybe it's a woman sitting across from me on a city bus downtown or something. Maybe she's with a child, and I start wondering what she's been through, what will the child go through. I start thinking about

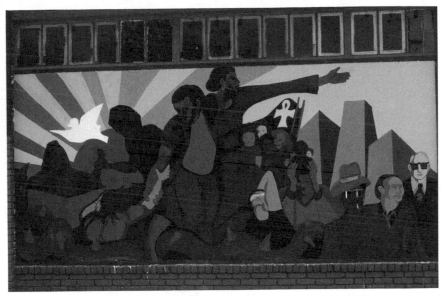

Above: Alcohol and Drug Prevention Center, Oakland, CCAC Mural Workshop, 1980; below: Centro Infantil de la Raza, Oakland, CCAC Mural Workshop, 1981.

their lives, and I start imagining, in my mind, what if this, or what if that, what if she's married and her husband is an abusive guy, what if she's here from Central America, or some other country. Little by little, when I'm home I am thinking about that. There are women I met in San Diego, crossing the border. You see these women and they're obviously trying to get across the border, and that's just really heartbreaking for me, mainly because of what they go through. You know, they leave a family, leave their relatives, they leave their homes, to cross over, to make a living, because their country was destroyed by our policies. Somehow we had something to do with it, whether it's through NAFTA or something else, that they were sort of expelled from the place they grew up or were born, and for sure they're going to be rejected on this side, you know. So a lot of the time you know the hardship they went through

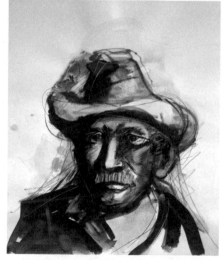

Above left: *La Sal de la Tierra*, screenprint, 2017; right: *De la Sierra*, mixed media, ca. 2010; opposite page, left: *Nicaragua Quien la Defiende es que la Ama Mas*, offset, 1979; right: *Undocumented*, screenprint, 1981.

to get here, and not be able to ever get back or to be separated, it's a heartbreaker.

You mentioned that this exhibit was in many ways inspired by your mother. You were born in Albuquerque, New Mexico, prior to World War II and grew up in the Central Valley of California. How did your family history influence your art and politics?

My mother was born in Albuquerque, up in the mountains; she married when she was thirteen. My father was a shepherd, a winemaker, a whiskey maker, and his life was, well, he just existed. Sometimes my mom would say that she was so young that she would forget she was married. So when he went off into the mountains for two or three weeks at a time, the next day she was playing dolls with her cousins. And then two weeks later you'd hear the thunder of hooves coming down from the mountains and all of a

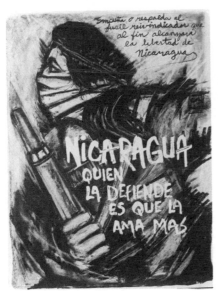

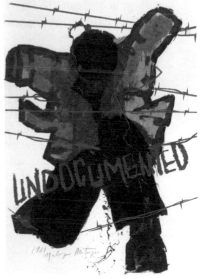

sudden she'd get picked up and thrown onto the saddle. It was my dad, saying "Now you have to come home and cook for me." And it was kind of sad, you know, because of him. I gave it a lot of thought when I was growing up, because my dad had all the power, but she had all the strength. And she was able to endure all of that. Before they got separated, I asked my mom, "Why don't you leave him? He's so mean." But then after they got separated, every time we went to church, my mother would give us a dime, or a nickel, and say, "Light a candle for your father. Send your father a card. Don't forget about your father."

As I grew up, I got really angry at the idea of having to light a candle for this man who was a horrible person. And one day I asked her, "Why do I have to light a candle for this person, he was so mean?" And she said, "Remember, mi hijo, my son, your dad was born just like you, he wanted all the same things, but something happened. Something went wrong with him." And yeah, I would just shine it off, but then as I got older I started to think, well, what could have gone wrong with my dad? Well, he couldn't speak English, he couldn't write in English, he couldn't write in Spanish, and he couldn't hold a job for those reasons. He did work for the WPA, but that was in spurts. So the only thing he had going for him was that he was a man, I guess, and that he had a house and a chair at the head of the table, so that was the only place he was someone, in his mind, and anything that went wrong would just set him off. So little by little, living in a racist society and all that, what he must have gone through, well, I never forgave him, but I understood what he must have felt like, and little by little, I started to think, well, it was the society we live in that made him go wrong, that couldn't allow someone like that. He was violent with us kids. There were times when I couldn't go swimming for a week or so, because of the beatings, the welts on my back. So it's 105° here in Fresno, and everyone was like, "C'mon, Malaquías, let's go swimming!" and I'm like, "No, I don't feel like swimming."

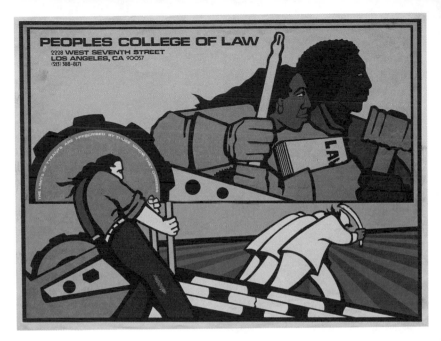

Above: *People's College of Law*, offset, 1976; below: *Chunky*, screenprint, 2016.

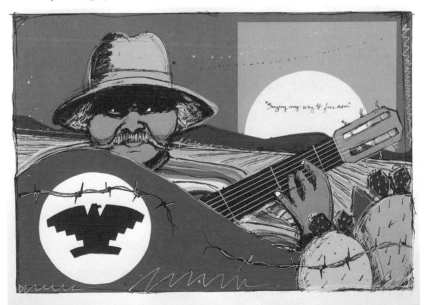

UNIDOS

TWLF

UN DAÑO CONTRA UNO ES
UN DAÑO CONTRA TODOS

VIVA LA RAZA UNIDA

MEXICANOS NOR PAPELES CHICANOS – CIUDADANOS

MEXICANOS SIN PAPELES

LA UNION HACE LA FUERZA
C.a.s.a.

THE CO-OP AND AZTLAN CULTURAL
INVITE YOU TO
A CHICANO CELEBRATION
OF TEACHER'S DAY
MAY 15
AT E.18TH STREET AND PARK BLVD. CO-OP
OAKLAND

MUSICA FOLKLORICOS MARIACHI
TEATRO REFERESCOS COMIDA

10 AM – 4 PM

UWW·B
UNIVERSITY WITHOUT WALLS
BERKELEY

NATIVE AMERICAN STUDIES DIVISION
2700 bancroft way
berkeley, california 94704

tel. (415) 548-0666

Did your mother work in the fields? What crops did you work in?

Yes, and she was a hard worker too. She would come home, we'd all come home, and then my dad would show up. And then, she was up all night making tortillas, making frijoles, getting everything ready for the next day. Then at four or four thirty in the morning she was up making everybody's lunch, getting everything ready, making sure everybody got up and got dressed.

There were four sisters and three brothers. We picked the grapes, turned them into raisins out in the sun, then you'd roll them up and they'd go to the packing house, and then they'd go into the Sun-Maid raisin box. We worked in grapes, peaches, and apricots. In the winter we'd pick cotton, this was in the late forties, early fifties, all up until I joined the marines in 1957.

Do you think that your family history played a role in your feelings about art and politics? Did you have any exposure at all to art during that period?

Growing up, drawing was the only thing I was good at. In elementary school that was the only thing I got kudos for, and it gave me sort of a good feeling. I was placed in a class that at that time was called a "mentally retarded" class, that later became also a "slow learners" class. And being children of farmworkers, we were allowed to stay out of school until the harvest was in.

And nobody gave a shit about whether you'd go to school?

No, no. When we went to school, it was already late September, even early October, and you were . . .

Behind already.

You were behind, and you had an accent, and you couldn't speak English properly. You missed a lot, especially in the first, second, and third grades, because you grasp so much at that time. So they put me in the class with the other Mexicanos, some African Americans, and maybe two or three of what we used to call Oakies. They lived in

our neighborhood, they were just as bad off as we were, except that they were white. But instead of helping us get ahead, the teacher would come in with a box full of paper, construction paper, pencils, crayons, chalk, whatever, and that's what we would do, pretty much all day long . . .

Draw.
Draw, color . . .

No math, no English?
Once a week, she'd put up math problems, and most of the time the answers were put up too, or there were English sentences that we would copy, but that was it, and then it was, "Okay, put your work away." And we would go back to our drawings.

What grade was this, third grade?
I think I was nine or ten, and I enjoyed it, because it put me in a class full of people who looked like me, and I could draw, I could draw the teacher, I could draw the bullies, and little by little I came to feel really good about who I was because I got so many compliments.

From who?
The other kids.

The teachers never complimented you?
No. I remember one day I sat down in class and I saw my name written in very large letters on the chalkboard, MALAQUÍAS. And of course the feeling in my stomach was, shit, what did I do now? What did I do now, maybe I did something good? So the teacher said, "Malaquías, will you come up?" She never could pronounce my name very well, she was always butchering it, and she said, "I have an idea. You know how the children sometimes can't pronounce your name?" And that was interesting because the kids had no problem pronouncing my name once they learned it. She took the eraser and

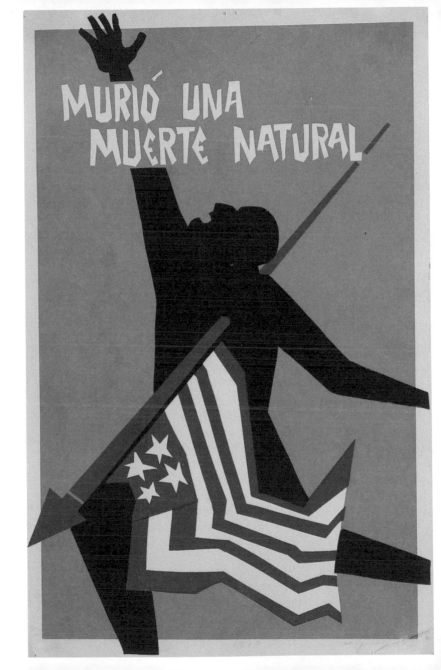

went "M-A-L" and then erased the rest of it. And all that was left was "MAL," and she said, "What if we called you Mal?"

That means "bad" in Spanish!

Yes, and I thought of that. And I also thought of Bob, and Jim, names with just three letters, and I thought, golly, I'll be just like the rest of the guys. My mom and my sisters were quite surprised, and a little bit angry. But I told them, "Ma, it's okay." So, from third grade on until I joined the marines, I was known as Mal.

Could you read and write?

Yeah, I could write, but it was hard. English classes for me were difficult. I stuck it out in high school, but it was really hard. I would get answers from friends, but it wasn't just copying the answers. I would look at the questions and then I'd look at their answers, and I'd say, "I'll be damned, I didn't know that."

You were learning.

Yeah, I was learning in my own way. When I got to UC Berkeley, there was a professor there in education, sociology, and he said, "Wait a minute. You said you cheated your way through high school but you ended up at Berkeley. How did you end up at Berkeley?" I told him what I would do, that I would find things where I said, "Golly, I didn't know that." Or I'd see something in a movie and I'd go, "I didn't know that." He said it was possible to learn that way, because you're not just copying; you're writing it down and thinking about it, doing something with it, pressing it into your mind. So yeah, I finished high school. I was active in high school. I was in two or three drama productions. I was in plays. I played almost all the sports, including football. They put me as center because that's where they put the Mexicans.

Were there artists or teachers you looked toward for inspiration?

There was a teacher from Persia who had a big influence on me; teaching me that art has a meaning, that it is valuable, not monetarily

but as a way of speaking. My senior year he and I had a rather bad collision. It was because he had done all this research for me to apply to the California College of the Arts—he was trying to get me scholarships. All I had to do was collect all my work and get a portfolio together. So he was very disappointed that he was doing all this work for me and I was not able to get the five or six sculptural pieces together. So, I felt very bad that I had let him down, and that he had tried hard.

I eventually spent a little time at Reedley Community College, where I played football for fall quarter. Later, I moved to Oakland and got a job working for a big can company and moved in with my brother who was going to CCAC at the time.

Later, I moved to San Jose, and got a job at an advertising company that needed a printer. I had taken a class in printing, printing with ink, you know, little pens. So I answered the ad and he asked me where I had printed, and I said, "I printed up near Fresno." I had no idea what he was talking about, I'm a printer, you know. So he said, "What kind of film did you use?" And I said, "Film? That doesn't have anything to do with printing." So we were sort of heehawing back and forth, and he said, "Have you actually ever silk screened?" And I said, "You know, I actually haven't." And he said, "Do you know what silk screening is?" And I said, "No, I actually don't."

So, he took me downstairs, and he had printing tables, with screens sitting up there. It was then that I realized that at that community college, in one of the classes, they had these little screens where the students would print these little Christmas cards. And I said, "Shit, I should have paid more attention." But anyway, he said, "Have you ever silkscreened before?" and I said no. So he said, "Well, you know what, you have a really nice smile, you're a real friendly guy. If you work for me for a month, for free, and remember, during that month, you're going to be learning a lot, if you do well, I'll hire you, for $1.25 an hour." I said, "Okay." So I worked for free for a month, and I would go back at night and try everything. I would draw, I just fell in love with that place. And at the end of six months he gave me an extra paycheck, for the month I had worked for free. I worked for him for almost seven years.

Clockwise, from top left: *Vietnam Aztlán*, offset, 1973; *George Jackson Lives*, offset, 1976; *Festival Aztlan at USC*, offset, 1981; *Health Workshops/Third World Women's Alliance*, offset, 1977.

When did politics come into your life?

Right around that time, because the farmworkers struggle had started, and down south the African Americans' struggle, and I was very moved by what was taking place, and their struggle for justice. My mom used to talk about *los negritos*, and how much they suffered, what they have to go through, and she'd say, "I wish we'd do whatever we could to help them, and not to tease them and make fun, because they're just like us." We were in real bad shape ourselves, but she was always ready to help somebody else. I also met [civil rights activist and Olympic runner] Harry Edwards at some event in San Jose, I think he was teaching and coaching at San Jose State, and he had been to Mexico for the '68 Olympics.

I was excited about what Cesar Chavez was doing, representing us, because I was one of *them*, you know. I felt good about what he was saying. I remember sometimes growing up, I would feel ashamed of my mom or my dad if they came to pick us up at school, because they never looked like all the other mothers and fathers; they were always dirty because they had been out in the fields, and they drove in to pick us up at three so we could go to work. So when I heard Chavez speak, when I saw him on television, I remember thinking that my mom and dad had actually *contributed* to the wealth of this country and I shouldn't feel embarrassed by them or feel bad for them, you know, that they were contributors to the wealth, so that made me feel good. I started going to San Jose State, and there was a group there called Los Hermanos (The Brothers), so I started hanging out with them. They weren't really talking politics but they were a group of guys who were hanging out together, from the same backgrounds, and they were the ones who started encouraging us to go to meetings, to check out CSO (Community Service Organization), the group where Chavez used to speak sometimes, and the inspiration I got from there was just invaluable.

That group changed its name into MASC (Mexican American Student Confederation), and I designed their logo. That's when it

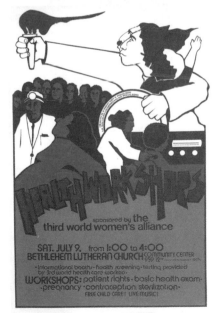

YO SOY CHICANO

A FILM DOCUMENTRY ON THE CHICANO EXPERIENCE
produced by jesús treviño

KCET/28
aug. 11 8:30 pm

started. I designed their logo for buttons, for T-shirts. Then San Jose State had a booklet and needed a drawing for it. So I started doing drawings for groups at San Jose State.

At about that time, I met Joseph Zirker who was teaching drawing at San Jose City College. He really liked my drawings, and he introduced me to the works of Diego Rivera, José Clemente Orozco, and David Alfaro Siqueiros, and I had never heard of them. I had never seen those works, works which are so goddamn inspiring that they blew me away. Zirker said you can take my classes if you want to, but there's not much I can teach you, you draw very well, and you come from such an incredible culture, and your background should give you so much to draw from. We talked about me going to UC Berkeley, because I had gotten into Berkeley. He was sort of concerned about my going there because, he said, art has changed so much, there's not a lot of professors at Berkeley that teach the figure. Most of them are into abstract, conceptual art, and all kinds of different art. He was concerned this would damage what I could contribute to, but he said, "If you insist on going in this direction, then you should look up Elmer Bischoff, who was a fantastic artist and painter who still worked with the figure as a subject."

Figures in art are hard to deal with, because sooner or later you have to give that figure a voice. It has to speak about something. And artists found abstraction easier because you didn't have to do that. Like, just making straight lines and throwing paint onto the canvas, by doing that you didn't have to give that human form a voice. But I need the figure because I wanted it to speak. I wanted to speak about farm workers, I wanted to speak about my mother, I wanted that voice to speak about the injustices taking place. So, in 1968, I went to Berkeley, and all shit was breaking loose there at that time. The grape boycott was taking place, demonstrations were taking place. When there was going to be arrests made for occupying the president's office, one of the organizers told me I shouldn't get arrested because propaganda was needed on the outside. So the next day I was out doing what I could, we had a cultural center where I

set up—printing posters to support those that had been arrested. I made posters, did fundraisers, made leaflets, flyers, designed material for the Third World Strike. So then it seemed I never went to class and all I did was posters.

And that was very bad, my hands had deteriorated over the eight years I printed with the solvents and the lacquer thinner. And for two years, during the day, I printed electronic circuit boards in Palo Alto, and for electronic circuit boards, instead of a silk screen, you use stainless steel mesh, and the only way you could get the film out of there was to use bleach. And of course you're supposed to have gloves, but you're always in such a hurry to put the bleach on that your hands just dry out real bad. And that's why I was looking forward to going to Berkeley, to stay away from screen printing and heal my hands. But immediately I got back in there and started working for the Third World Strike. I never went to class; I just ran posters.

It sounds like your politics were basically developed out of the social movements that were going on at the time. But you hadn't felt that when you were a young boy?

Well I was upset at the way things were going when I was growing up. I had to watch my mother sometimes being scolded by the grocery store guy because she didn't pay her bill, and she didn't speak English very well. I had to try to explain things to him. I would tell him that every winter, after the season, that we would come in and pay our bill. "Well Malaquías, I can't just be having hangers-on, I need my money also." So, those kinds of things. And just noticing how ranchers lived, compared to their farmworkers, those kinds of things were always in my mind.

So when I started drawing, the first drawings I did were always about people that I knew, which were farmworkers. The early drawings I did, the early silk screens that I did, were all about farmworkers. So that's why when Cesar Chavez started asking me to do posters for them, it was the most natural thing for me to do.

When I went to Berkeley, the art the professors were doing was terrible and so hard to digest. I remember one particular professor

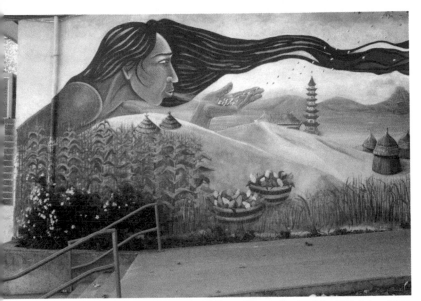

Ulatis Elementary School, Vacaville, CA, UC Davis Chicano Studies Mural Workshop, 1997.

said, "Well, Malaquías, if you don't like that class, why don't you take my class?" So I went to visit his office, and he had giant canvases, but they were all like chevrons, you know, military chevrons, huge. I stood there thinking, "How could a grown man sit there all day long just painting stripes?" I didn't tell him that, but I did say that my schedule wouldn't work for taking his class. One professor brought me work, saying, "Here you go . . . if you do these drawings, they will bring you in a little money, put a few frijoles on the table." So finally I would do my work in my studio at home. And the work I did at that time was political, it was very critical of the church and of the police brutality that was taking place.

So during that period you became kind of one of the go-to guys for posters and prints. How did that happen? People would come to you and say, "We need this, we need that?" Did you ever get paid for your work?

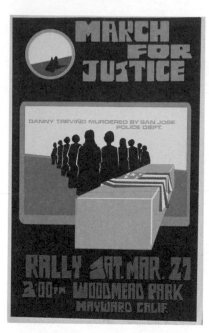

MARCH FOR JUSTICE

DANNY TREVIÑO MURDERED BY SAN JOSE
POLICE DEPT.

RALLY SAT. MAR. 27
2:00 PM WOODMEAD PARK
HAYWARD CALIF.

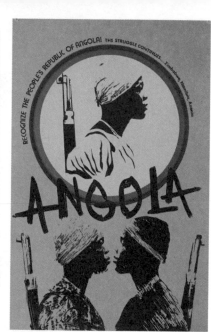

RECOGNIZE THE PEOPLE'S REPUBLIC OF ANGOLA! THE STRUGGLE CONTINUES... Zimbabwe, Namibia, Azania

ANGOLA

LATIN AMERICAN DEPARTMENT
MERRITT COLLEGE

Know Your
RACE
(AZTEC)
CONOZCA
SU RAZA

CHICANO STUDIES • ENROLL NOW
5714 GROVE STREET, OAKLAND

MAY
DANCE
3

SAT. 8pm 2pm
Tickets: $4.50
$5.00

CINCO DE MAYO

BENEFIT

BANDS:
"CHE PFEG & HIS ALL STAR BAND"
"UNIDAD"
"LOS UNIVERSALES"
LOCATION: RICHMOND CIVIC AUDITORIUM CIVIC CENTER AVE.
Sponsored by: CHICANO STUDENT UNION
(contra costa college)

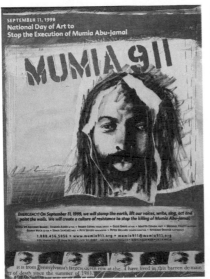

Opposite page, clockwise from top left: *March for Justice*, screenprint, 1976; Angola, screenprint, 1980; Cinco de Mayo Benefit at Contra Costa College, screenprint, 1975; *Latin American Department at Merritt College* (collaboration with Manuel Hernandez), offset, 1969. This page, clockwise from top left: *Mumia 911*, offset, 1999; *Bakke*, screenprint, 1977; *Dennis Banks Legal Defense*, offset, 1975.

No, no. Sometimes they would pay for materials but because I could get paper from the university, for a class, I wasn't worried about the supplies. In fact I would help people in the community, using the students' labor we would do a lot of posters. There was a Black cultural center, and we had a workshop in the back that was tied to Laney and Merritt College so we would get students from Laney and Merritt to come there and we would get supplies, not much, but we did.

Were their artists working around the same time, designing political posters, etc., that you particularly admired?

Artists from the Royal Chicano Air Force such as Rudy Cuellar, Louie the Foot, and my brother—Jose Montoya, and Esteban Villa. Later, Juan Fuentes, Melanie Cervantes, Jesus Barraza, Rupert Garcia, and Ester Hernandez.

At the time, there were all kinds of political movements developing from the farmworkers, Marxist-Leninist movements. Did any of those movements interest you or were you more interested in the more practical approaches?

The Socialist Workers' Party was big in Fruitvale, but I never really belonged to any of those groups, although I attended a lot of meetings at the time. As long as there wasn't any conflict, I would do a poster for whoever asked me. Whoever asked me to do a poster, as long as we were going in the same general direction, I would do it. Might be different ideas, different approaches, different directions, but as long as we agreed the outcome was going to be the same.

Your art is certainly informed by the social movements of the 1960s and 1970s. What role do artists play in the age of Trump?

I see their role as the same as ever; the artist is to give voice to the issues that are given to us in a confused manner, so that people can understand the role that they must play. I think the role of the cultural worker is to define in a clear way, those things we receive from those that are in power, and give it to the community and present it in a clearer way, so they can understand what it is we're supposed to do.

Because of technology, a lot of people are doing things through the computer. And they can create a lot of posters and a lot of artwork. But the role of the artists when we were in Oakland, in Fruitvale, was to create a community. That was what was important. Yes, it's to create art, but also to have a place where the community could come and have a safe place to discuss issues, to learn about what was going on. It was an incredible place to reach people because you could have a lady cutting a stencil next to you, an elderly lady, and you could be talking with her about this young man in Oakland, Jose Barlow Benavidez, who was killed by the police. And you could explain to her how it happened, why it happened, and make it into a larger picture. You could explain the war in Vietnam, which was on everyone's mind, and you explain why they're there. A lot of people would ask, "Why do you do these posters about Angola? There's nobody here from Angola!" Same with Central America. So you could make them understand, somehow make the world closer, make them understand that what's happening here is also happening in Angola, and Central and South America, by the same people who create poverty here. And that was so easily done around a table cutting stencils. And they would ask questions about what certain things meant, and that was the role I think of the cultural centers, centros, or talleres, to bring the community in.

So do you think building community is happening today or has social media displaced that?

I really just don't know. I don't even use a computer, I'm computer illiterate, but I don't see it happening so much. I know people that can create many, many images on the computer. I think it was Doug Minkler who told me, "The problem with technology is that I design a poster for a group, doing work with Palestine, and I hit the send key, and get a message back an hour or so later, 'Thank you very much, Doug. It's beautiful. We'll let you know when it's done.'" And he said, "You know, Malaquías, I never shook anybody's hand. No one ever said, 'Hey, thank you,' or gave me a hug. It was all virtual."

So returning to the exhibit downstairs, *La Fuerza* is it? The one that you did for last year's Women's March? What inspired that?

Just the idea of women protesting and coming together. I was just at the taller in Woodland and sketched it out and I said, gee, there's a lot of people going to Sacramento tomorrow, so I did forty or fifty of them, and when the different groups came by the workshop to pick up any posters we might have, I gave them out.

Seems to me, as I listen to you, I'm kind of tearing up here, because it seems to me that in some ways, the project grew out of your love and care for your mother.

Yeah.

That your mother was such a pivotal person in your life.

She was, and I remember my sisters, they would come by my mom's house and have breakfast and then go on to church. When they found out I wasn't going to church anymore they told mom, "Mom, Malaquías isn't going to church anymore. He's changed a lot." And my mom said, "How has he changed? He looks the same." And they said, "He doesn't go to church anymore." And she said, "Well, maybe he'll go another time." And they said, "Creamos que es comunista—we think he's a communist." And my mom said, "Well, as long as Malaquías keeps on doing what he's doing, as long as he keeps working for los pobres, the poor people, God will always have a place for him." So I looked at my sisters and I said, "See!"

Overall, the work is about women I have encountered some way, somehow. Like there's one up there of just a woman looking down, and there's a little handwriting on the side that says, "After he left, I looked out the window, and for the first time I saw flowers growing." And so many women I know who have gone through crises, divorces, or being in grief, or in some abusive relationship, I can imagine them doing something like that, I can imagine them seeing flowers that they didn't even know were out there because their lives had been so dark all this time, their lives had been so enclosed, so I

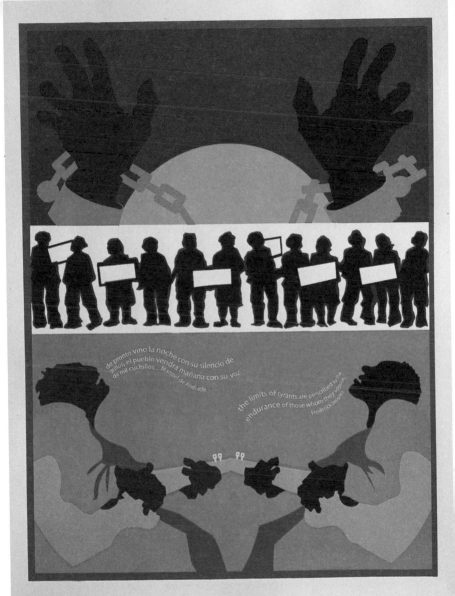

de pronto vino la noche con su silencio de
grillos, el pueblo vendrá mañana con su voz
de mil cuchillos... Manoel de Andrade

the limits of tyrants are proscribed by the
endurance of those whom they oppress.
Frederick Douglass

think it's that sense of liberation for them, like there's another one that says, "We were all sick but we were going to die anyway. So we decided we would keep fighting." But again, the theme, the idea comes from the idea that there's a lot of women like my mother out there.

One other sort of technical question, about how you work, when you see the lady on the bus, do you sketch her right then? Or sort of recreate the person later?

I'm able to recreate the image later, or something like that. I have so many images in my mind from the last few years, like a woman climbing a ladder with a fifty-pound sack of cotton and shaking it, and then getting $1.50. And they didn't get any kind of, they weren't taken out to dinner at the end of the week, they just had the same every day, the only joy they had was taking care of their children, seeing that they were healthy and they were going in the right direction, growing up.

In addition to supervising the mural at Markham Elementary school, what are you working on these days?

I have been preparing for a forty-piece exhibition and catalogue, called *Voice for the Voiceless,* which opened in October at California State University, Stanislaus. *Voice for the Voiceless* will then travel to Fresno State University, and they too will be producing a catalogue. The show will be on display during the month of February.

I just completed a commissioned print from the Oakland-based Greenlining Institute. I will also be producing the fiftieth-anniversary print for Centro Legal de la Raza in Oakland. It's my anniversary print, one that I have produced for them for each of the last five decades. **S**

Many thanks to Maceo Montoya for the images. Thanks to veteran journalist and activist Bob Barber for recording and transcribing the interview.

SAT. MARCH 12 FARMWORKERS BENEFIT

SALSA DE BERKELEY
GRITO
APUMEC HALL 3256 E. 14 st. oakland ca.
3.00 ADV. 3.50 DOOR
INFO. 533-3477

8 PM

CONTRIBUTORS

Bill Berkowitz is an Oakland-based freelance writer known for his coverage and critique of the Far-Right.

Erik Buelinckx lives in Brussels and from time to time ventures away from his books for actions about paperless people, police repression and other worthy causes. An anarchist and art historian, he is interested in the relationship between art and anarchy in Belgium and elsewhere, from the mid-nineteenth century to the mid-twentieth century.

Alec Dunn is an illustrator, a printer, and a nurse living in Portland, OR. He is a member of the Justseeds Artists' Cooperative.

Mehdi El Hajoui has been researching and collecting the Internationale Situationniste and its aftermath for the last decade. He was the winner of the Jay I. Kislak Foundation Student Book Collecting Competition in 2010, and he completed the Colorado Antiquarian Book Seminar (CABS) in 2015. He is a graduate of Harvard University with a master's degree in Romance languages and literatures. Check out his blog at https://situationnisteblog.com/.

Josh MacPhee is one of the founders of Interference Archive, organizes the Celebrate People's History Poster Series, and is a member of the Justseeds Artists' Cooperative.

John Morrison is a Philadelphia-based DJ, producer, and music journalist (Red Bull Music Academy, *Jazz Right Now*, *Bandcamp Daily*, and more). His debut instrumental hip hop album *Southwest Psychedelphia* is a psychedelic trip through a day in the life of his Southwest Philadelphia neighborhood, available now on Deadverse Recordings.

Jordi Padró is a graphic designer and member of the Centre de Documentació de l'Esquerra Independentista.

Natalia Revale is an artist, ceramicist, and teacher from Buenos Aires. She is a founding member of Arde! Collective action art (2002–2006 and 2011–2014), Escultura Popular (2006–2009), Muralismo Nómade en Resistencia (2014–present), an organizer in the graphic campaign Vivas nos Quieres (2015–present), and part of Editorial El Colectivo (2012–present). Since 2015, she has curated the visual arts space FM La Tribu with Javier del Olmo. Her work focuses on interventions in public spaces and territories and explores the axis of memory and human rights.

SIGNAL:01 Taller Tupac Amaru ● Dutch Red Rat Comic ● Graffiti Writer IMPEACH ● Radical Imprint Logos ● The Graphics from Mexico 1968 ● Adventure Playgrounds: A Photo Essay ● Anarchist Designer Rufus Segar SIGNAL:02 Japanese Anarchist Manga ● Freedom: Anarchist Broadsheets ● Oaxacan Street Art ● Rode Mor: Danish Collective ● Revolutionary Murals of Portugal ● Malangatana: Revolutionary Mozambican Painter ● Gestetner Printing SIGNAL:03 ● South Africa's Medu Arts Ensemble ● Paredon Records ● Deltor: Anarchist-Communist Collages of the 1930s ● Graphics from the 2012 Quebec Student Strike ● Spanish Anarchist Newspapers Mastheads ● Yugoslav Partisan Memorials SIGNAL:04 Palestinian Affairs Magazine ● Street Art Concerning the Juarez Femicides ● Antimilitarist Peace Navy ● Toronto's Punchclock Press ● New Zealand Political Posters ● Kommune 1: Berlin's 1960s Counterculture ● Three Continents Press SIGNAL:05 Emerging Print Collectives ● Displacement and Design in Barcelona ● Political Prints from 1970s Uruguay ● NYC's Come!Unity Press ● Italian Political Records ● The Pyramid as Symbol of Capitalism SIGNAL:06 Stickers from the German Antifa, 1970s Portugal and the IWW ● The Appalachian Movement Press ● Mexican Collective ECPM68 ● 1970s Asian American Resistance in NYC ● Lebanese Collective Jamaa Al-Yad ● Incite! 1980s Bay Area Anti-Imperialist Collage

"If you are interested in the use of graphic art and communication in political struggles, don't miss the latest issue of *Signal*."
— Rick Poynor, *Design Observer*

PM Press is an independent, radical publisher of books and media to educate, entertain, and inspire. Founded in 2007 by a small group of people with decades of publishing, media, and organizing experience, PM Press amplifies the voices of radical authors, artists, and activists. Our aim is to deliver bold political ideas and vital stories to all walks of life and arm the dreamers to demand the impossible. We have sold millions of copies of our books, most often one at a time, face to face. We're old enough to know what we're doing and young enough to know what's at stake. Join us to create a better world.

We seek to create radical and stimulating fiction and non-fiction books, pamphlets, T-shirts, visual and audio materials to entertain, educate, and inspire you. We aim to distribute these through every available channel with every available technology—whether that means you are seeing anarchist classics at our bookfair stalls; reading our latest vegan cookbook at the café; downloading geeky fiction e-books; or digging new music and timely videos from our website.

PM Press is always on the lookout for talented and skilled volunteers, artists, activists and writers to work with. If you have a great idea for a project or can contribute in some way, please get in touch.

PM PRESS
PO Box 23912
Oakland, CA 94623
510-658-3906
www.pmpress.org